World of Dance

Asian
Dance

SECOND EDITION

World of Dance

World of Dance

Asian Dance

SECOND EDITION

Janet W. Descutner

Consulting editor:
Elizabeth A. Hanley,
Associate Professor
Emerita of Kinesiology,
Penn State University

Foreword by
Jacques D'Amboise,
Founder of the National
Dance Institute

CHELSEA HOUSE
P U B L I S H E R S
An imprint of Infobase Publishing

World of Dance: Asian Dance, Second Edition

Copyright © 2010 by Infobase Publishing

Chelsea House
An imprint of Infobase Publishing
132 West 31st Street
New York NY 10001

Library of Congress Cataloging-in-Publication Data
Descutner, Janet.
 Asian dance / by Janet W. Descutner. — 2nd ed.
 p. cm. — (World of dance)
 Includes bibliographical references and index.
 ISBN 978-1-60413-478-0 (hardcover)
 1. Dance—Asia. I. Title. II. Series.
 GV1689.D47 2010
 793.3'195—dc22 2009019582

Chelsea House books are available at special discounts when purchased in bulk quantities for businesses, associations, institutions, or sales promotions. Please call our Special Sales Department in New York at (212) 967-8800 or (800) 322-8755.

You can find Chelsea House on the World Wide Web at
http://www.chelseahouse.com

Text design by Kerry Casey
Cover design by Alicia Post
Composition by EJB Publishing Services
Cover printed by Bang Printing, Brainerd, Minn.
Book printed and bound by Bang Printing, Brainerd, Minn.
Date printed: January, 2010
Printed in the United States of America

10 9 8 7 6 5 4 3 2 1

CONTENTS

INTRODUCTION

The world of dance is yours to enjoy! Dance has existed from time immemorial. It has been an integral part of celebrations and rituals, a means of communication with gods and among humans, and a basic source of enjoyment and beauty.

Dance is a fundamental element of human behavior and has evolved over the years from primitive movement of the earliest civilizations to traditional ethnic or folk styles, to the classical ballet and modern dance genres popular today. The term *dance* is broad and, therefore, not limited to the genres noted above. In the twenty-first century, dance includes ballroom, jazz, tap, aerobics, and a myriad of other movement activities. The joy derived from participating in dance of any genre and the physical activity required provide the opportunity for the pursuit of a healthy lifestyle in today's world.

The richness of cultural traditions observed in the ethnic, or folk, dance genre offers the participant, as well as the spectator, insight into the customs, geography, dress, and religious nature of a particular people. Originally passed on from one generation to the next, many ethnic, or folk, dances continue to evolve as our civilization and society change. From these quaint beginnings of traditional dance, a new genre emerged as a way to appeal to the upper level of society: ballet. This new form of dance rose quickly in popularity and remains so today. The genre of ethnic, or folk, dance continues to be an important part of ethnic communities throughout the United States, particularly in large cities.

When the era of modern dance emerged as a contrast and a challenge to the rigorously structured world of ballet, it was not readily accepted as an art form. Modern dance was interested in the communication of emotional experiences—through basic movement, as well as

uninhibited movement—not through the academic tradition of ballet masters. Modern dance, however, found its aficionados and is a popular art form today.

No dance form is permanent, definitive, or ultimate. Changes occur, but the basic element of dance endures. Dance is for all people. One need only recall that dance needs neither common race nor common language for communication; it has been, and remains, a universal means of communication.

The WORLD OF DANCE series provides a starting point for readers interested in learning about ethnic, or folk, dances of world cultures, as well as the art forms of ballet and modern dance. This series features an overview of the development of these dance genres, from a historical perspective to a practical one. Highlighting specific cultures, their dance steps and movements, and their customs and traditions underscores the importance of these fundamental elements for the reader. Ballet and modern dance—more recent artistic dance genres—are explored in detail as well, giving the reader a comprehensive knowledge of the past, present, and potential future of each dance form.

The one fact that each reader should remember is that dance has always been, and always will be, a form of communication. This is its legacy to the world.

In this volume, author Janet W. Descutner describes in detail the various dances of India, Southeast Asia, China, and Japan. These Asian dances have been intertwined with religion throughout history; both Hinduism and Buddhism were vehicles for spreading dance throughout Asia, and dance was often seen as a way to placate the gods/spirits and narrate the struggle between good and evil.

Dance in Asia, however, is not tied to religion only; it is a reflection of society—historically, politically, and culturally. From the classical dance of southern India to the fascinating dances of Thailand and Bali, from the classical Chinese opera to the minority folk genres in China, and from the traditional theater dances of Japan to the modern Butoh dance of that nation, Asian dance provides great diversity for both performer and spectator.

One of the most well-known Asian celebrations is the Chinese New Year and China's "lion dance." No matter the meaning, dance in Asia is

an important form of expression and will continue to be admired for its varied performance styles and movements, colorful and elaborate costumes, and skilled performances.

—Elizabeth A. Hanley
Associate Professor Emerita of Kinesiology at
Pennsylvania State University

FOREWORD

In song and dance, man expresses himself as a member of a higher community. He has forgotten how to walk and speak and is on the way into flying into the air, dancing. . . . his very gestures express enchantment.
 —Friedrich Nietzsche

In a conversation with George Balanchine (one of the twentieth century's most famous choreographers and the cofounder of the New York City Ballet) discussing the definition of dance, we evolved the following description: "Dance is an expression of time and space, using the control of movement and gesture to communicate."

Dance is central to the human being's expression of emotion. Every time we shake someone's hand, lift a glass in a toast, wave good-bye, or applaud a performer—we are doing a form of dance. We live in a universe of time and space, and dance is an art form invented by human beings to express and convey emotions. Dance is profound.

There are melodies that, when played, will cause your heart to droop with sadness for no known reason. Or a rousing jig or mazurka will have your foot tapping in an accompanying rhythm, seemingly beyond your control. The emotions, contacted through music, spur the body to react physically. Our bodies have just been programmed to express emotions. We dance for many reasons: for religious rituals from the most ancient times; for dealing with sadness, tearfully swaying and holding hands at a wake; for celebrating weddings, joyfully spinning in circles; for entertainment; for dating and mating. How many millions of couples through the ages have said, "We met at a dance"? But most of

10

all, we dance for joy, often exclaiming, "How I love to dance!" Oh, the JOY OF DANCE!

I was teaching dance at a boarding school for emotionally disturbed children, ages 9 through 16. They were participating with 20 other schools in the National Dance Institute's (NDI) year-round program. The boarding school children had been traumatized in frightening and mind-boggling ways. There were a dozen students in my class, and the average attention span may have been 15 seconds—which made for a raucous bunch. This was a tough class.

One young boy, an 11-year-old, was an exception. He never took his eyes off of me for the 35 minutes of the dance class, and they were blazing blue eyes—electric, set in a chalk-white face. His body was slim, trim, superbly proportioned, and he stood arrow-straight. His lips were clamped in a rigid, determined line as he learned and executed every dance step with amazing skill. His concentration was intense despite the wild cavorting, noise, and otherwise disruptive behavior supplied by his fellow classmates.

At the end of class I went up to him and said, "Wow, can you dance. You're great! What's your name?"

Those blue eyes didn't blink. Then he parted his ridged lips and bared his teeth in a grimace that may have been a smile. He had a big hole where his front teeth should be. I covered my shock and didn't let it show. Both top and bottom incisors had been worn away by his continual grinding and rubbing of them together. One of the supervisors of the school rushed over to me and said, "Oh, his name is Michael. He's very intelligent, but he doesn't speak."

I heard Michael's story from the supervisor. Apparently, when he was a toddler in his playpen, he witnessed his father shooting his mother; then, putting the gun to his own head, the father killed himself. It was close to three days before the neighbors broke in to find the dead and swollen bodies of his parents. The dehydrated and starving little boy was stuck in his playpen, sitting in his own filth. The orphaned Michael disappeared into the foster care system, eventually ending up in the boarding school. No one had ever heard him speak.

In the ensuing weeks of dance class, I built and developed choreography for Michael and his classmates. In the spring, they were scheduled to dance in a spectacular NDI show called *The Event of the Year*. At the

boarding school, I used Michael as the leader and as a model for the others and began welding all of the kids together, inventing a vigorous and energetic dance to utilize their explosive energy. It took awhile, but they were coming together, little by little over the months. And through all that time, the best in the class—the determined and concentrating Michael—never spoke.

That spring, dancers from the 22 different schools with which the NDI had dance programs were scheduled to come together at Madison Square Garden for *The Event of the Year*. There would be more than 2,000 dancers, a symphony orchestra, a jazz orchestra, a chorus, Broadway stars, narrators, and Native American Indian drummers. There was scenery that was the length of an entire city block and visiting guest children from six foreign countries coming to dance with our New York City children. All of these elements had to come together and fit into a spectacular performance, with only one day of rehearsal. The foremost challenge was how to get 2,000 dancing children on stage for the opening number.

At NDI, we have developed a system called "the runs." First, we divide the stage into a grid with colored lines making the outlines of box shapes, making a mosaic of patterns and shapes on the stage floor. Each outlined box holds a class from one of the schools, which consists of 15 to 30 children. Then, we add various colored lines as tracks, starting offstage and leading to the boxes. The dancers line up in the wings, hallways, and various holding areas on either side of the stage. At the end of the overture, they burst onto the stage, running and leaping and following their colored tracks to their respective boxes, where they explode into the opening dance number.

We had less than three minutes to accomplish "the runs." It's as if a couple of dozen trains coming from different places and traveling on different tracks all arrived at a station at the same time, safely pulling into their allotted spaces. But even before starting, it would take us almost an hour just to get the dancers lined up in the correct holding areas offstage, ready to make their entrance. We had scheduled one shot to rehearse the opening. It had to work the first time or we would have to repeat everything. That meant going into overtime at a great expense.

I gave the cue to start the number. The orchestra, singers, lights, and stagehands all commenced on cue, and the avalanche of 2,000 children were let loose on their tracks. "The runs" had begun!

After about a minute, I realized something was wrong. There was a big pileup on stage left and children were colliding into each other and bunching up behind some obstacle. I ran over to discover the source of the problem: Michael and his classmates. He had ignored everything and led the group from his school right up front, as close to the audience as he could get. Inspiring his dancing buddies, they were a crew of leaping, contorting demons—dancing up a storm, but blocking some 600 other dancers trying to get through.

I rushed up to them, yelling, "You're in the wrong place! Back up! Back up!"

Michael—with his eyes blazing, mouth open, and legs and arms spinning in dance movements like an eggbeater—yelled out, "Oh, I am so happy! I am so happy! Thank you, Jacques! Oh, it's so good! I am so happy!"

I backed off, stunned into silence. I sat down in the first row of the audience and was joined by several of the supervisors, teachers, and chaperones from Michael's school, our mouths open in wonder. The spirit of dance had taken over Michael and his classmates. No one danced better or with more passion in the whole show that night and with Michael leading the way—the JOY OF DANCE was at work. (We went into overtime, but so what!)

—Jacques D'Amboise
Author of *Teaching the Magic of Dance*, winner of an
Academy Award for *He Makes Me Feel Like Dancin'*,
and Founder of the National Dance Institute

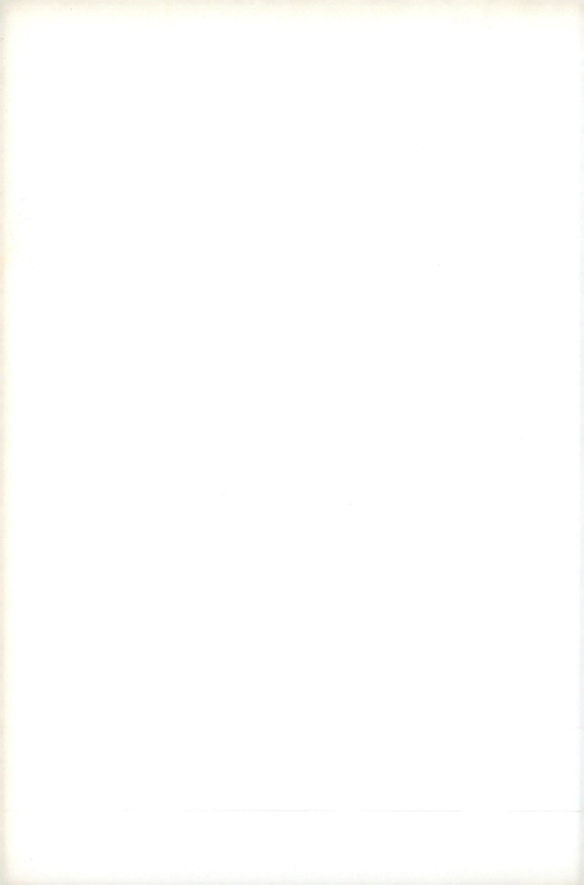

Perspectives of Human Culture and Development

We can watch dancing and admire it on the basis of its visible, physical qualities: the rate of speed, whether incredibly fast or mesmerizingly slow; the organization, style, and manipulation of rhythm; the choice, uses, and range of motion of body parts; and the costume and decorative accessories that help identify its origins and locale.

Developing an understanding of those choices, however, entails more than the examination of the dance's outward appearance. In some cases, we must look to long-ago origins, thousands of miles and/or centuries away from the current community in which we find the performance. Its study incorporates perspectives from *anthropology* (the study of human cultures) and *dance ethnology* (studying the process of dance in culture), as well as observing and analyzing the specific dance content (*choreography*) of a culture. Using these perspectives, we hope to understand the origins, phenomena, and current impact of the dance on society.

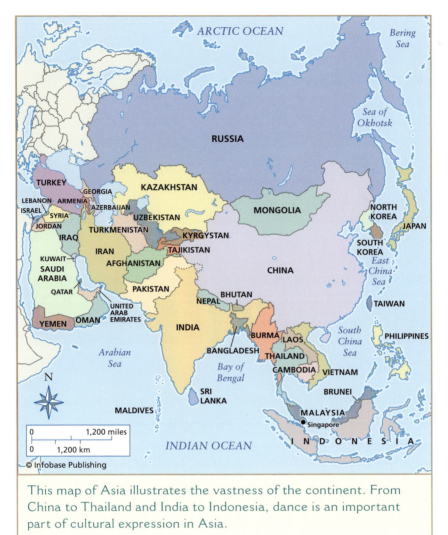

This map of Asia illustrates the vastness of the continent. From China to Thailand and India to Indonesia, dance is an important part of cultural expression in Asia.

Asia is a series of large landmasses and island cultures, with many distinct geographies, climates, and views of existence. The dances discussed in this text developed in the regions stretching from India through Southeast Asia that include Thailand, Cambodia, Vietnam, and Indonesia, and north through China into Korea and Japan. Surprisingly, from very early times, travel throughout Asia was common despite the distances and challenges of terrain and the differences between travelers and the cultures with which they came in contact.

Hsuan-Tsang, a Chinese Buddhist monk, was one of Asia's early explorers. He wrote an astonishing record of his travels to and throughout India, beginning in A.D. 629.[1] After 16 grueling years on foot, horseback, camel, and elephant, as well as living in Indian Buddhist communities, where he stayed with the monks and studied the *sutras* (teachings of the Buddha), he returned safely to the T'ang capital in 645 and recorded his journey in *Si-yu-ki: Buddhist Records of the Western World.*[2]

Despite this early travel, it wasn't until the twentieth century that increasingly swift transportation worldwide helped open Asia's doors for information gathering. The availability and variety of perspectives from which that information has come has provided a rich amount of material for the study of arts practices on an international scale. Particularly valuable are the many videotapes of Asian dance—some reproduced from films no longer viewable—made in the first half of the twentieth century.

Early films capture the unique quality of the dances in their historical environment. They provide an important resource for study of the forms as they were danced prior to the influence of tourism. Later, when these dances were presented out of context in locations arranged for the convenient viewing of tourists, both form (particularly length) and content changed as a result. This effect can be seen in many of the tapes made since the 1970s, in which shortened or modified forms are presented as the norm.

Unlike most dance forms of Western cultures, Asian dance and theater were developed primarily in response to sacred beliefs, which encouraged direct visual engagement with sacred objects and subjects. Hinduism was the dominant religion in southern India, and "seeing the divine," or *darsan* (pronounced "darshun"), was a major purpose for temple worship and offerings.[3] For centuries, Hindu populations gathered outside temples at dusk after their day's fieldwork to view and learn about the Hindu deities through dramatic performance, song, and dances, in which hand gestures symbolized images related to the gods and their relationships with each other.

India's numerous images that represented the various aspects of the divine, as well as their mythology and legends, developed over centuries and were preserved and passed on through oral tradition. Later, performance practices were described in the *Natya Sastra*, a book attributed to

the sage Bharata, which is also the ancient name for India. The text, written around the time of Christ, describes in detail the theory and performance practices of Indian theater and dance arts from ancient times.[4]

These dance forms, along with Hindu beliefs, were transported to the East by Indian merchants and travelers who followed the oceanic currents in search of trade. According to ethnomusicologist Dr. William P. Malm,[5] "Indian influence and Brahman Hinduism entered Java in the first and second centuries A.D."[6] Malm also pointed out that ancient Hindu Vedic hymns were brought to Yüshan, China, where they were heard by Japanese Buddhist monks in the T'ang dynasty courts. The monks then brought the hymns to Japan.[7]

During the sixth to eighth centuries, Indian musicians were part of the Japanese emperors' court musicians and dancers. Five hundred performers of different styles of Japanese court music (*gagaku*) and dance (*bugaku*) were grouped according to their geographic origins and form or style. The gigantic drums, which were marked with the intertwined flame symbols related to Indian Shiva worship, as well as the yin-yang symbol of Taoist China, suggest the combination of influences from India and China. India's religious traditions and arts were admired and adopted by the Japanese and eventually merged with Japan's music, dance, and belief systems. Japan's Shinto religion, which can be translated as "continuity," and music of gagaku and bugaku, like the other traditional Japanese forms of music and dance, can still be heard and seen in the Imperial palace today. Gagaku and bugaku were presented to the international public in a performance during the coronation of Emperor Akihito in 1989, viewable on the tape series *Dancing*.[8]

THE DANCE SYMBOL

Professor Emerita Allegra Fuller Snyder pioneered the developing field of dance ethnology. It is her definition, "studying the process of dance in culture," that was included in paragraph two of this chapter.

Snyder was one of the founders and developers of the dance ethnology program at the University of California at Los Angeles. She introduced her concept of "the dance symbol," a framework for the study of

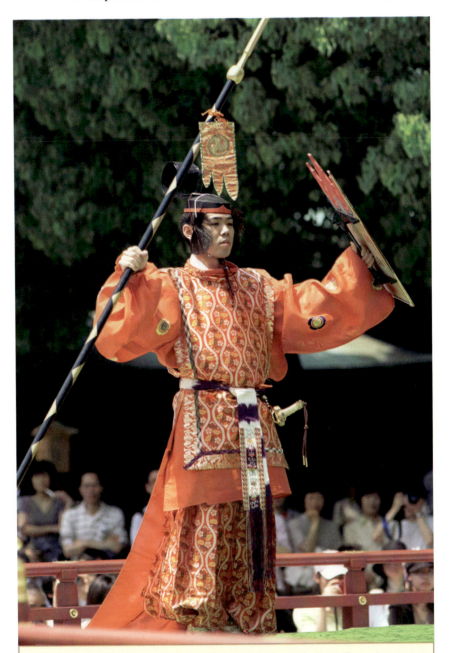

A bugaku dancer performs at the Meiji Jingu Spring Grand Festival Celebration in Tokyo. Bugaku is a traditional Japanese court dance performed primarily by men, on rectangular, raised stages.

dance embedded in traditional cultures, at the 1972 Conference of the Congress on Research in Dance (CORD).[9]

In this succinct presentation, Snyder observed that dance has had the most significant impact on societies that were nonliterate (had no written language). In these cultures, dance performance has been the vehicle around which the community recalled and sustained its history, mythology, aesthetics, philosophy, and environmental needs. In this role, Synder asserted, dance teaches self-knowledge as well as information about human relations. The dancer's act of performance "embodies both self-identity and worldview,"[10] incorporating the three elements of the dance symbol to communicate. Those elements are movement, costume, and *paraphernalia*.

Snyder describes the sum of the parts of this communication as a "very basic equation . . . the dance symbol (movement, costume, and paraphernalia) = environment, subsistence pattern, mythic complex."[11]

This seemingly simple symbol, as presented by native Balinese in the *Tjalanarong Drama of Rangda* (witch) and *Barong* (mythical beast who resembles a cross between a lion and a bear), is described by Jane Belo, an author who lived among the Balinese in the 1930s, as " . . . a deeply complex, laminated structure, layers upon layers of meaning reaching down into the present out of a foggy or accurately recorded past . . . "[12]

It is in the movement that Snyder feels we can identify an environmental or subsistence-level connection; for example, the specific way of moving may be derived from work patterns in acquiring food. In the case of the Balinese, the signature male walking style in dance, with knees and feet lifted high, directly up from the ground toward the hip joints, can be seen in the way workers move through the wet rice fields, lifting the foot directly up out of the mud in a spokelike pathway. The up-and-down movement of this dance may also relate to the mythic complex and geography of Bali, in terms of the significance of direction—up (*kaja*) toward the central, holy mountain, Gunung Agung, and down (*kelod*) toward the earth, where witches dwell, or to the sea, which is home to demons.

The tense holding of the lifted shoulder girdle, darting eyes, and quick movements of the head connect to the mythic complex as well,

in which being alert is essential in detecting the presence of demons at crossroads.

Ben Suharto, a Javanese court dancer, wrote the article "Transformation and Mystical Aspects of Javanese Dance" in the *UCLA Journal of Dance Ethnology*. Javanese Yogyakarta dance transforms the dancer into someone else through physical means, but it is the dancer's goal to achieve a state of emptiness so that only the character he is playing can be seen. The personality of the dancer is denied so that it becomes secondary to the expression of his inner quality, or spiritual aspect. As Suharto writes, "Since he operates from the state of emptiness or nothingness, he has the freedom to express the character of the evil giant while not becoming evil."[13]

In each of these cases, the dancer experiences transformation through what Snyder calls the "conceptual kinesthetic"—a movement event that takes the dancer to a "world of heightened sensitivity" or another level of consciousness that is beyond mere movement. The stimulation and transformation, which occur within the dancer and those who are present, create a sense of unification within the group or society. The events may be rites of passage that cure or unite the group, control the forces of nature, or relate to seasonal change.

RELIGION AND DANCE

The close historical relationship of dance to religious practices in the countries of Asia makes it useful to understand the nature of religions as social institutions and how religion functions to provide expressive and substantive needs within human culture. Dance is not only movement selected and determined as significant for its beauty and interest as physical performance; it also brings experiences that occur in the here and now into a culture's mythic and spiritual worldviews, reflecting ancient religious beliefs and practices while embodying them in present-day performance.

The following definitions of religion by anthropologists Clifford Geertz and Melford Spiro were developed by each scholar over time, drawn from many cultural examples, and intended to apply to any institution that satisfies the functions described above. Together they

constitute two complementary and meaningful frameworks for exploring the dances of Asia.

Geertz, an anthropologist who pioneered the study of culture as a symbolic system and has done extensive field research in Bali and Java, proposed the following definition:

" . . . a religion is (1) a system of symbols which acts to (2) establish powerful, pervasive and long-lasting moods and motivations in men by (3) formulating conceptions of a general order of existence and (4) clothing these conceptions with such an aura of factuality that (5) the moods and motivations seem uniquely realistic."[14]

Note that Geertz does not specify the presence of a god in his definition, although one can be implied as part of the symbol system; thus, Buddhism is included, although the system Buddha created and taught was a series of practices of the self that do not include a godly figure.

In South and Southeast Asia, dance has historically been a particularly effective promoter of such symbols, and it continues to be, although its role has been affected in many ways by the advance of colonialism and the developments of the twentieth century. As you investigate the dance cultures explored in this book, apply the five parts of Geertz's definition to consider how dance operates within the culture to fulfill these functions.

Anthropologist Melford Spiro defines religion as "an institution consisting of culturally patterned interaction with culturally postulated superhuman beings."[15]

Spiro specifically includes the concept of gods, as well as practices that relate them to humans. He says that, in the absence of alternative institutions (such as science or technology), the institution of religion provides the means for satisfying three basic human desires/needs:

- **Cognitive needs**: knowledge—the need to know, to understand the unknown and unexplainable (such as the questions Huston Smith asks at the beginning of his text, *The Illustrated World Religions*: "Where are we? Why are we here? What does it all mean? What, if anything, are we supposed to do?")[16]
- **Substantive needs**: those required for individual subsistence and persistence such as personal health provided by food, clothing, shelter, water; and societal and community needs

such as those provided by rain, crops, good hunting, warmth, victory, and healing.

- ◆ **Affective needs**: emotional balance, freedom from inner conflict, which causes expressive needs (painful drives, repressed hostilities, culturally forbidden acts and feelings, Hinduism's *moksha*—release from reincarnation—which occurs after the soul has evolved through cycles of being and non-being until it achieves permanent release from earthly lives).

Spiro points out that to obtain these needs, humans connect themselves to the superhuman world through the following domains using cognitive, substantive, and affective acts or connectors:

- ◆ **Cognitive domain**: We create myths and beliefs that answer the need to know (based, to a certain extent, on local phenomena to provide proof of their truth).
- ◆ **Substantive domain**: We perform acts of ceremony—dance, drama—to achieve success in obtaining substantive needs or helping us to adapt to circumstances as they are.
- ◆ **Affective domain**: We create a link through expressive acts, which transfer these inner conflicts from the actual world to a symbolic one to enable us to make them more tolerable by integrative means.

While many scholars have defined religion, these two anthropologically-based definitions are particularly useful and applicable as a framework for examining the roles of dance in context. For example, dramatic and choreographic performances present the epic myths, character, and deeds of heroic Indian deities such as Krishna, who come to humans' rescue in times of social turbulence or provide affection and emotional security. Dance also represents historical as well as mystical phenomena in Indian, Thai, Balinese, Javanese, Chinese, and Japanese dance theater. In Bali, trance dances embody the presence of both malevolent and beneficent spirits, whose actions are essential to overcome evil or drive away sickness.

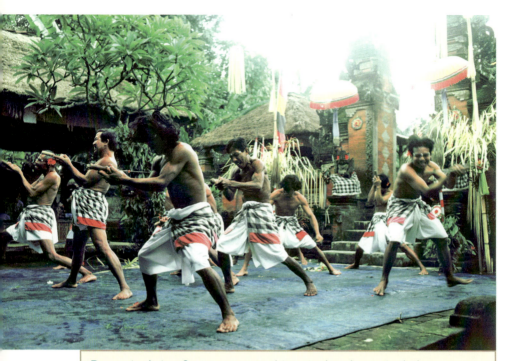

Dance in Asia often represents historical and mystical phenomena. Here, Balinese trance dancers incorporate the presence of malevolent and beneficent spirits, whose actions are necessary to defeat evil or eliminate sickness.

MOVEMENT LEXICONS

The elements of dance—how the performance employs the human body in time, space, energy, and flow to create a meaningful communication—comprise movement lexicons. This term refers both to the movements themselves and the language used to describe and talk about elements of a genre. For example, traditional American jazz dance lexicon includes action such as torso "contraction" and "hyperextension"; body part "isolations," such as oppositional shifts of the head, rib, or pelvis; and "jazz" characteristics derived from American music of the 1910s, 1920s, and 1930s. These elements include attention to rhythmic accents, both on- and off-beat, and textural qualities: sensuous, grounded, and vibratory. Many of the characteristics of this contemporary American form are derived from movement employed in the African dances of imported

slave populations as well as twentieth-century borrowings from South Indian dance, particularly movement isolations in the torso and a serpentinelike quality in the arms.

In contrast, American ballet lexicon typically employs an extended and lifted torso, extreme range of motion in the legs emphasizing highly developed outward rotation, and unique equipment (toe shoes or soft slippers). It also takes place indoors, preferably on a resilient wood floor of a proscenium stage, with the audience seated, directly facing the action. Although its origins can be traced to couple dancing of the fifteenth and sixteenth centuries in Italy and France, the ensuing developments into an art of the twenty-first-century stage drastically maximized its physical demands as it developed into classical ballet.

Sweeping, arcing actions lift the legs and arms to the periphery of space around the dancer. Some of the dances are abstract, choreographed for the display of physical technique; others relay a traditional folktale (*Cinderella*, *Swan Lake*) or examine a contemporary drama or subject (*Undertow*, *Stars and Stripes*). Generally, it is not considered essential for the audience to have an extensive musical background in order to appreciate the event; however, the performer's physical gifts and training set her/him apart as a unique instrument.

Bharata natyam is a traditional female solo dance form in Tamil Nadu, Southeast India. This dance form also emphasizes outwardly rotating thighs, which shifts the emphasis of the pelvis downward into the feet and releases the tension in the opened thighs. The dancer wears anklets that consist of as many as 100 bells each. She performs complex rhythmic accompaniment, lifting the bare feet directly up toward the pelvis in spokelike paths, then percussively striking the marble surface of the floor. The arms and hands are highly active, presenting arclike pathways above and around the torso, along with shapes and actions of the hands called mudras, which represent objects (such as flowers, birds, and the moon), as well as concepts or attributes (such as cleverness, anger, and radiance). Other specific hand poses symbolize particular deities (thumb up with fingers closed refers to Shiva, the deity who sets the world in motion and consumes it with fire).

The subject of the dance is generally related to highly familiar actions and relationships of Hindu deities. Portions of the dancer's performance mime words of the story, emphasizing the feelings she is experiencing

toward the deity—the object of her devotion. The hands form a variety of shapes that represent flowers, birds, turtles, weapons, and the flowing hair of Shiva, the deity responsible for cycles of time. The feet and legs actively sound out complex rhythms made audible by the multiple strings of bells worn on the dancers' ankles.

The knowledgeable audience for Indian dance forms is expected to have a sophisticated understanding of the rhythmic cycles danced by the performer and expressed by musicians through drums, flute, and voice. Precursors of this solo dance were performed in both temple and palace for many centuries. The dance was performed in honor of the Indian deities, who were believed to have an impact on how the community would fare. By honoring the gods through dance and music, favors related to community prosperity might be obtained. However, in the late nineteenth century, under British rule, the dance, called *Sadir*, and the dancers—*devadasis*, which literally translates as "female slave (or servant) of God"—became stigmatized due to the increasing practice of prostitution by financially needy priestess dancers. Bills prohibiting the dedication of young girls to temples soon spread throughout southern India, and only when a group of the Brahmin class revived and renamed it Bharata natyam (literally, dance—*natya*—of ancient India—*Bharata*) did it begin to make a return to public performance in the mid-1930s.

Contemporary dancers now perform in music academies or on stages rather than at temples. Although the dance's topics are still based on the Hindu deities and speak to Hindu members of the audience, a dance viewer need not have an extensive or sophisticated understanding of the stories and rhythmic system to appreciate the physical content and respond to the sight, sound, and energies of the dance.

The choices of lexicon—how a culture thinks of and uses the body and environment for sustaining the group both physically and psychologically—may be explained by examining the early history of a society's environment and the development of its worldview and means of subsistence: how food was obtained, who/what is responsible for human continuation, and how the community can sustain equilibrium in the face of natural disasters.

India: The Divine Dance of Life and Death

India has a long, rich history of language, music, and dance integrated into its belief systems, rituals, and performance practices. India's people are racially diverse, consisting of three general types who developed from the merging of indigenous populations and recurring waves of incoming northerners between 4,000 and 2,500 B.C. These groups of people included the Caucasoid, in the northern regions of India and of Aryan descent—light-skinned, with long, narrow noses; the Mongoloid, from the eastern realm, at the foothills of the Himalaya Mountains (Manipur is in this region)—with round faces, broad noses, and eye set typical of East Asian peoples; and the Veddoid, or proto-Australoid, from the middle and southern regions—with curly hair, dark skin, round faces with broadened, flat noses, and low foreheads, similar to today's Australian Aborigines.

Although racial bias persists in Asia, as it does elsewhere, and light skin is socially desirable, it has not resulted in the sort of social and political tension in India that has occurred in the United States. The traits of these three groups are predominant in some tribes or castes and mixed in others: For example, in parts of southern India, people can be found who have European facial features but very dark skin. In general, the tensions that have developed in India are due more to competing religious issues

than to racial ones. The multiplicity of religious denominations includes various sects of Hindu, Muslim, Christian, Buddhist, Jainist, and Sikh. Hinduism is not a conversion faith—one must be born into it—and historically it has been as much a social system as a religious institution.

With its religious and racial diversity, India has more than 15,000 separate languages and four major language families. Of these four, the two largest are Indo-Aryan, in the same family as the languages of Europe, whose speakers live in northern and middle India, and Dravidian, languages of the southern region and unique to India. There are large numbers of local dialects. One of the many sublanguages of Indo-Aryan is Hindi, which was eventually intended to replace English as the national, or official, state language, following India's political independence in 1947. However, controversy still surrounds this issue, primarily because it would require that 80 percent of the population learn a new language. Tibeto-Burman and Austro-Asiatic are the remaining two language groups. Language, then, is another prominent focal point for regional patriotism and, along with religious tensions and those caused by the caste system, is an added threat to India's political unity.

DIVERSITY OF GEOGRAPHY, CLIMATE, AND TERRAIN

The geographies and climates of India are also in distinct contrast, ranging from the tropical rainforests of Kerala and Assam to the desert of Rajasthan and the mountainous regions of the Himalayas. Monsoons of tremendous destructive power can cause seasonal floods and cyclones but are welcomed because they follow months of dryness and are essential to the next crop.

HISTORICAL AND MYTHOLOGICAL DEVELOPMENT OF HINDUISM

The beginnings of recorded information were documented by a pre-Aryan (around 2000 B.C.) Indus Valley civilization that developed in the plain encompassing the Indus River. It was centered around the two large cities of

Mohenjodaro and Harappa and located in what is currently Pakistan, west of present-day India. This Indus Valley civilization was pastoral and agricultural, worshipping fertility gods of both genders. Archeological studies have uncovered physical evidence of a well-established ritual life.

In Harappa, phallic, or *lingam* in Hindu terms, evidence of worship is typified by carved stone seals showing a seated god with crossed legs and bull's horns. In addition, mother-goddess cult seals feature depictions of plants growing from the womb of a female deity or images of human sacrifice before a nude female deity. Other animals and combinations of different animals accompany the figures.

In Hinduism, Shiva takes on some of the same features: He sits cross-legged, the bull is his symbol, and his consort Sati is associated with human sacrifice. In southern India's dance gesture, the upheld thumb may refer to the lingam and, therefore, symbolically, to Shiva or to the strong characteristics he displays. His name is pronounced in different ways: one like *she + wa*; another, similar to *shiver* with the *r* unpronounced. Both have a softened "sh", rather like the sound of *s + y*.

In 1700 B.C., there was a wave of conquest of the Indus River Valley by northern people, *Aryas*—a Sanskrit term meaning "nobles"—whose skin was light and who were at a much lower level of cultural development. Not city dwellers, they were nomadic horsemen and warriors; their gods were connected with the universal elements (sky, sea, wind, lightning, and rain) rather than the soil. Gradually the indigenous and invading cultures melded both socially and in their mythic complexes, blending into the Hindu culture that predominates (as recently as the late 1970s, 83 percent of India's population was Hindu). *Indus* is the word from the Indo-Aryan language of these invaders for the dwellers they found in the Indus Valley, and *Hindus* were those who lived and worshipped like them.

As the population moved eastward, the Ganges River system was revealed to be the Hindus' significant icon, not only as a source of water but, more important, as the center for spiritual activity. Daily bathing in the Ganges's waters still remains an act of devotion as well as earthly cleansing. The many names given to the Ganges suggest the ongoing reverent attitude toward this enduring and significant natural resource: "The Pure, The Eternal, The Light Amid the Darkness, The Cow Which Gives Much Milk, The Liberator, The Destroyer of Poverty and Sorrow, and The Creator of Happiness."[17]

MOGUL INVASIONS

Another series of invasions had great influence on the dance of India. The onslaught of the Moguls (Muslims) from the North, and their subsequent rule from the twelfth through the eighteenth century, had a profound effect on northern-style dance, *Kathak*, because Muslims believe that representing God in any form is a sacrilege. Consequently, the subjects of the dances, previously Hindu gods, were secularized into love poetry about human feelings, and the performance moved from the temples to the palaces of the rajas. Emphasis shifted from an expressive, devotional nature to a skilled, brilliant performance with physical and poetic beauty, as well as sensuousness.

Other arrivals affected the development of dance. Portuguese traders and missionaries landed in Kerala, on the southwestern Indian coast, in 1498, beginning a long line of trading powers that came from Europe. Costumes of *Kathakali*, a dramatic, storytelling form, show the possible influence of Portuguese fashion. No local rationale can explain the heavy, long-sleeved jackets and weighty, close-fitting headdresses that are worn in such a humid, hot climate, or explain the hoopskirtlike garments that enlarge the presence of the actors or make them appear to be hovering above clouds as they converse and dance their stories.

Sikhs, a small but sizable segment of the Indian population, were a fifteenth-century off-shoot of Hinduism in reaction to the caste system. The other tenets of their beliefs have remained consistent with Hinduism. Theirs is but one upheaval over the social inequity rigidly protected by the prohibitions of intercaste mobility. In the latter half of the twentieth century, they have revolted against the prevailing Hindu government with assassination and temple desecration.

MYTHOLOGICAL BACKGROUND: COSMOLOGY[18]

In the video series *The Long Search*,[19] the tape *Hinduism: 330 Million Gods* presents many of the concepts below from the perspective of

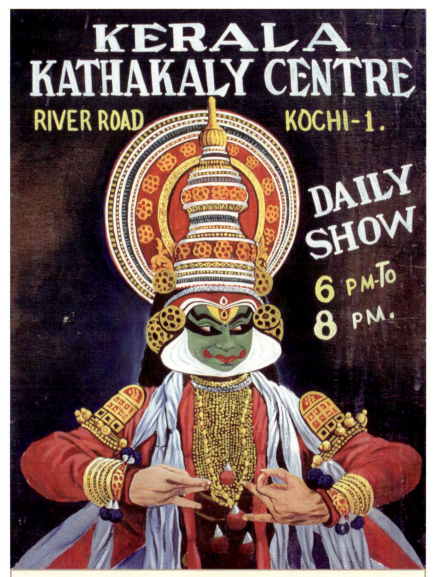

Kathakali is a popular dance drama of southwestern India. This poster advertises the daily performance of the dance drama at the Kerala Kathakali Centre, in Kochi, India, which has been featured on the National Geographic and Discovery channels.

Indians living in twentieth-century India, while *Origins of India's Hindu Civilization*[20] provides an effective overview, incorporating images from Indian arts and environment.

Cosmology is a civilization's philosophy of the origins, structure, and processes of the universe. Hinduism has a complex and ancient cosmology. It begins with the Vedas—Aryan hymns from about 800 B.C. —which inform us of the characteristics of the early deities. Varuna, prime mover, creates the universe by exercise of his creative will, or *maya*. Varuna is also a god of sun, rain, and wind, and he is embodied in his own creation: The sun is his eye and he props up the heavens. Gradually some of his attributes are passed on to other gods and a multiplicity develops: First a divine triad, then others are added—wind, fire, sun, and dawn. Indra, a storm god who wields a thunderbolt and rides in a golden chariot pulled by a horse, had a violent nature and was invoked to bring rain. Each of these gods developed elaborate mythologies that gave them human personalities. They began to encompass activities of other gods and the divisions blurred, but none was supreme lord.

The Brahmanic age resulted in the emergence of Brahma, whose priests, the *Brahmins*, were powerful and developed the practice of sacrifice through elaborate rituals. At this phase, the concept of universal time as a never-ending cycle of both creation and destruction developed. Each complete cycle, which is 100 years in the life of a Brahma, dissolves in a great cataclysm and is followed by 100 years of chaos. Then a new Brahma is born and the cycle starts again. One of Brahma's days is equivalent to 4,320 million years on Earth. Elaborate descriptions detail what happens in the cycles of destruction as well as the new creation.

Brahma eventually became identified with Brahman, the world spirit: the "Non-Personal Supreme One," who pervades and transcends all things. He becomes the "Great Principle" (of beingness, life essence, and spirit, referred to as the "Unknown Knower," or more abstractly, as pure potential, or "suchness").

At the same time, Brahma also is seen as one of the *Trimurti* (trinity) of deities. His aspect was Creation. In this Trimurti, Vishnu was the kind and compassionate Protector, or Preserver, whose reincarnations, called *avatars*, help humans in distress. Shiva, the Destroyer, is the embodiment of energy that consumes, dancing his powerful and dark side in cremation grounds. While each of the three has his role as designated above, there is tension among them, particularly between Brahma and Shiva, who, individually, are thought of as creative and in control of the universe.

Mirroring these powerful images is *Shakti*, who personifies the dynamic, manifesting energy that creates the universe, as opposed to the static, unmanifested aspect of divine reality that male energy produces. Shaktis are sometimes the males' consorts (lovers, wives) and other times appear in their place.

Shaktis of the Trimurti are Sarasvati, Lakshmi, and Parvati. Sarasvati (also spelled Saraswathi) is the patroness of the arts and learning, mother of the Vedas, and Brahma's consort, or shakti, image. Lakshmi is the consort, or shakti, of Vishnu and "mother of the world." Noted for her devotion to Vishnu, she, too, is reincarnated as the consort, or shakti, aspect of each of his avatars.

Shiva's first consort was Sati, the devoted, self-sacrificing wife whose immolation was the model for the practice of *suttee*, the custom of widows committing suicide by throwing themselves on the dead husband's funeral pyre.

Parvati became Shiva's second shakti. Parvati once was Shiva's competitor in a dance contest, which he won by extending his leg very high, an action that Parvati's modesty prohibited.

Shiva is the master of austerities. These austerities—denials of the flesh and rejections of life's pleasures—give him his power and make him a model for the Indian yogi, who rejects the pleasures of life and practices denial. Shiva is also the bringer of fertility, which associates him with creation. This supreme creative power is celebrated in the worship of the lingam. It is this representation of him that we see in the heart of the temple in the videotapes *Hinduism: 330 Million Gods* and *The Cosmic Dance of Shiva*. He is often depicted as a demon slayer and the distributor of the seven holy rivers, including the Ganges, the holiest of rivers. In the center of his forehead is a third eye, which is used as a powerful weapon of destruction by fire.

Shiva also is recognized in his role as Nataraja, Lord of the Dance (nata = dance, raja = king, or lord). He is the cosmic dancer who sets the earth in motion and destroys it with fire every 10,000 years. Shiva defeats *maya*, which is often symbolized in Indian iconography as a dwarf or serpent being crushed beneath a dancing foot that is destroying this life, this world of separateness, in order to achieve union with Brahman. The rhythm of time and its cycles is symbolized in this image by the ring of fire and circular motion surrounding Shiva as he initiates

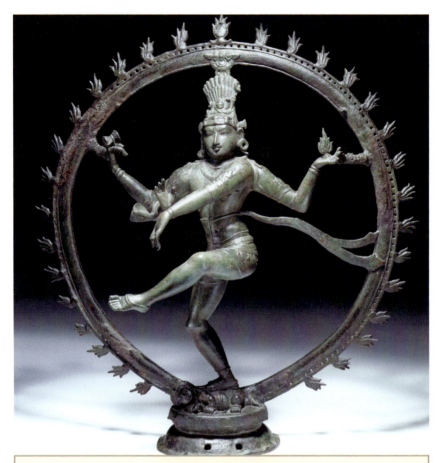

This twelfth-century sculpture from Tamil Nadu, in southern India, depicts the god Shiva. One of the primary Hindu gods, Shiva is known for his role as Nataraja, or Lord of the Dance.

or halts a time cycle. The drum he holds high in his right hand signifies the rhythm and passage of time. His dance in this aspect of his energy is the *Nadanta*, which is danced in a temple in Chidambaram, a town in southeastern India. Diana's *Darsan*[21] contains a compact description of the major symbols of Nataraja. A more extended description of Shiva's symbolic attributes can be found in Ananda Coomaraswamy's *The Dance of Shiva: Essays on Indian Art and Culture*.[22]

In the view of Hinduism, maya is the human illusion that the material world is *atman*—that living beings are separate entities. While we cycle through our human lives, maya deludes us into believing that we

exist to gain material possession, satisfy human desires, achieve economic success, and enjoy social respect through service, rather than to achieve release from these fruitless pursuits and return to Brahman in spiritual union.

The *Tandava*, which is performed in cremation grounds or in cemeteries, is Shiva's dance of destruction. In this dance, Shiva, in his many-armed form, destroys the illusory world, maya, allowing atman (individual souls) to flow into Brahman.

Shiva's shakti aspect, or female energy, is called *yoni*. Shiva's negative shakti aspects—known by the names Kali, Durga, and Devi—are frequently associated with his bloody rites and depict the female as destroyer, black, and evil. Devi performed a Tandava that corresponded to Shiva's dance of destruction. In it, she flourished 1,000 destructive arms, defeated the demon Durga, and henceforth took the demon's name. Because of his dual nature as creator and destroyer, Shiva also has negative male aspects. Bhairava, the many-armed destroyer pictured in the videotape *Cosmic Dance of Shiva*,[23] is one of them. Shiva likes to dance in joy or sorrow, alone or with one of his shaktis, such as Devi or Parvati; for as the god of rhythm, he preserves the continuum of time and the eternal movement of the universe with his dance.

Other symbolic images of importance include two related to physical gender: the lingam and yoni. The lingam is the phallic, symbolic representation of Shiva and the male principle. Temples are often in this form, and Buddha's stupa headdress and the large columnar stupa monuments that are found in the landscape throughout Southeast Asia are also iconographic manifestations of this symbol. The yoni symbolizes the vulva, a circle at the base of the lingam, and represents Sati, or shakti, the receptive, female principle. The joining of the lingam and yoni are metaphors for the perfect union of atman with Brahman, leading to human freedom from reincarnation and pointing toward "pure potential."

Ganesha (also called Ganesh and Ganapati) is the elephant-headed son of Shiva and Parvati, who received that unique head when Shiva, not knowing that he had a son, thought that the beautiful young man was Parvati's lover and cut off his head. When Shiva was informed of the truth, he sent servants running to find the first living thing (an elephant), cut off its head, and restore his son to life by placing the head on his shoulders. The benevolent, sometimes amusing pachyderm is

often danced and depicted in sculpture and painting. He is the deity who overcomes obstacles. Lord Ganapati/Ganesh is associated with knowledge and wisdom. In Bali, he represents both the thirst for education and the reverence for teachers; in Thailand, he is the patron of artists. Ganesh is fond of sweets and has a round tummy to prove his affection.

Vishnu is important in the perspective of dance, due to his avatars, or reincarnations, in the form of Parasurama, the sixth avatar. Parasurama's stories of disagreement and war form the *Mahabharata*, which means "Tales of the Great Wars of India." The epic of Rama, the seventh avatar, is the *Ramayana*. These tales are the foundation for temple dramatic dance forms such as Kathakali, which educate and reinforce the reality of the gods in Hindus' daily lives.

Krishna, the eighth incarnation of Vishnu, is similar to Greek mythology's Dionysus. Krishna is known as the "Blue God" due to his deep blue skin, and he has great beauty and enjoys many amorous adventures. He is noted for his affairs with the *gopis*, cowgirls who were married but became infatuated with him and sought physical union, which symbolized *ananda*, or union with the divine. Krishna's shakti aspect, or consort, is Radha, and his assistance to the warrior Arjuna on the eve of the final bloody battle in the *Mahabharata* is dramatized in the *Bhagavad Gita*, one of the important writings about Hinduism's history, as well as one of the examples of Kathakali dancing in the *JVC Video Anthology of World Music and Dance*.[24]

Krishna is a popular figure in dances of all regions. His romantic exploits with the gopis, his stormy relationship with his consort, Radha, as well as his pranks as a child are depicted in Kathak, Manipuri, Bharata natyam, and Odissi dance.

Rama and Krishna were reincarnations (avatars) of Vishnu and figure prominently as subjects of dance and as kingly dancers. Sita and Radha—the consorts or Rama and Krishna—are reincarnations of Vishnu's consort, Lakshmi; their in-kind devotion to these avatars of Vishnu is the subject of much of the danced mythology, and they embody *bhakti* (religious devotion) yoga. Just as the dwarf is crushed by Shiva, Muyalaka, who represents maya, is also crushed underfoot as Krishna dances to defeat Kaliya, a six-headed serpent. The *Gita Govinda* is the story of Krishna/Radha and the gopis and,

together with Shiva hymns, is the subject of much of the Bharata natyam dances of the region of Tamil Nadu.

Two great Hindu epics provide the subject of dance and dramatic presentation throughout the various countries of Asia. Treatment of the subject and point of view depends to a great degree on the pathways of importation and how the material was incorporated into local tradition.

The *Ramayana* tells the story of Rama and Sita, who fight the demon Ravana with the aid of Hanuman, the king or lead general of the monkey army and a favorite character throughout Asia. Hanuman is known for his antics and bravery, and is a model for his devoted duty to his master.

The *Mahabharata* features the Pandava family. Arjuna is befriended and advised by Krishna, preceding the final battle against their half-brothers, the Kauras, and their allies. These epics are the source of much dance drama in Kathakali. A helpful summary of these two classic tales, which are known throughout Asia due to the early spread of Hindu culture, can be read in Jukka Miettinen's *Classical Dance and Theatre in South-East Asia*.[25]

The *Natya Sastra*, often referred to as the fifth Veda, is a book on dramatic arts (which includes dance in ancient cultures such as India, Greece, and China). Bharata Muni is the sage credited with its authorship, but the text probably is a collection of works written over a period from 500 to 250 B.C. by authoritative writers on various aspects of Sanskrit theater. Mythologically, Shiva was said to have dictated the content of this book to Bharata Muni, giving humankind the knowledge of music, dance, and aesthetic enjoyment (*rasa*). This array of deities is only a small part of those described in the *Rig Veda*, the four books of Hindu thought, a juncture of Aryan and Dravidian deities and ethics, originally chanted as an epic poem. The number and variety of gods would seem to classify Hinduism as polytheistic, which means the belief that there are many separate gods and that each individual essence must be placated through worship.

However, as clarified by the video *Hinduism: 330 Million Gods*, Hinduism provides these different entities as pathways to the truth—Brahman—not an anthropomorphic representation in the form of yet another god, but "pure potential." The term used by Donald and Jean Johnson to reflect this religious worldview is *monism*: the belief that all things are

part of one essence. According to the Johnsons, India's many gods are all just "arrows pointing to 'thatness,'" Oneness, or Brahman. In Hinduism, individual souls (atman) are also part of this collective soul and recycle through reincarnations until complete union with Brahman is achieved. In each of these incarnations, we build up a repertory of deeds, which are both positive and negative aspects of the overriding moral law of cause and effect: *karma*. It is our karma that we "work out" in reincarnations, seeking release (moksha) from the wheel of recycling souls by decreasing negative karma.

One of the ways Hindus historically have achieved this goal is by *darsan*—seeing and being seen by the divine. Viewing is attained via statues on temple structures, either carried aloft during festivals or in small replicas in the home. Today, this also may take place in the dressing room of a performer of Bharata natyam, Kathakali, or the other classical forms seen in India and around the world.

The abstract visualization of the "between life" periods reveals that each atman is not only also part of Brahman but is linked and part of every other atman, not individuated from other living beings. This image represents the progress of each soul to a more integrated state, further along the pathway to *satori*—enlightenment, freedom from the wheel of karma or reincarnation, and the achievement of moksha.

RHYTHMIC SYSTEM OF INDIA: TALA

The time cycles that figure in India's worldview are manifested in the structure of Indian music; and music lovers, as well as musicians, use physical gestures to keep track of that structure. The reader is encouraged to use her/his hands as she/he reads and absorbs this introduction to Indian rhythms.

Tala is made up of cycles of beats, subdivided into smaller units of different lengths and speeds, and tracked through specific hand gestures. *Kriyas* are gestures of different parts of the hand—hand clap, wave of the hand, finger counting—used in marking the beats or counts of the tala. Start with the little "pinky" finger, touching each fingertip to the palm

of the other hand or on another surface such as the thigh or the arm of a chair. *Angas* are sections of the tala composed of one or more kriyas. These include *anudrutam*, a fixed anga of one beat marked by hand clap (abbreviated A in the examples to follow); *drutam*, a fixed anga of two beats marked by a clap and a wave (abbreviated D); and *laghu*, a variable anga marked by a clap plus finger counting (abbreviated L, f). There are five patterns, or *jatis*, of these laghu:

tisra:	clap plus two finger counts	(3 beats)	L f f
caturasra:	clap and three counts	(4 beats)	L f f f
khanda:	clap and four counts	(5 beats)	L f f f f
misra:	clap and six counts	(7 beats)	L f f f f f f (ends with pinky finger)
sankirna:	clap and eight counts	(9 beats)	L f f f f f f f (ends with middle finger)

THE 35 TALA SYSTEM

There are seven categories of tala, each composed of a different arrangement and number of angas. The laghu in each tala group has five possible jatis, which makes 35 different talas. All the laghus in a tala must be of the same jati—clearly a complex system about which we will not attempt to do more than gain an entry-level understanding.

Three Sample Categories of Talas

Eka tala: composed of one laghu (all are only one unit of organization)

1. **Tisra eka:**	L+f f (shortest tala)	3 beats
2. **Caturasra eka:**	L+f f f	4 beats
3. **Khanda eka:**	L+f f f f	5 beats
4. **Misra eka:**	L+f f f f f f	7 beats
5. **Sankirna eka:**	L+f f f f f f f f	9 beats

Triputa tala: composed of one laghu and two drutas (two units of organization)

1. **Tisra triputa**:	L+f f+D+D	7 beats (3+2+2)
2. **Caturasra triputa**:	L+f f f+D+D	8 beats (4+2+2) (Popular for dance, called Adi Tala)
3. **Khanda triputa**:	L+f f f f+D+D	9 beats (5+2+2)
4. **Misra triputa**:	L+f f f f f f+D+D	11 beats (7+2+2)
5. **Sankirna triputa**:	L+f f f f f f f f D+D	13 beats (9+2+2)

Jhampa tala: composed of one laghu, one anudrutam, and one drutam

1. **Tisra jhampa**:	L f f+A+D	6 beats (3+1+2)
2. **Catusra jhampa**:	L f f f+A+D	7 beats (4+1+2)
3. **Khanda jhampa**:	L f f f f+A+D	8 beats (5+1+2)
4. **Misra jhampa**:	L f f f f f f+A+D	10 beats (7+1+2)
5. **Sankirna jhampa**:	L f f f f f f f f+A+D	12 beats (9+1+2)

All of the prior information is about the Tala structure, or *outer* rhythm. Once a piece begins in a certain tala, the counting and marking of beats remains fixed.

A significant element for the Indian dancer or musician is a clear understanding of inner rhythm or pulse (*gati*). Gati is the numerical relationship between the pulse and the beat; that is, how many places within each beat there are to sing a note, strike the drum, slap the foot, etc. This is similar to tactus in Western music but much more developed.

There are five main gatis. Their ratios of pulses to beat are as follows:

1. **Tisra gati**: 3:1 6:1 12:1 etc. (three subdivisions of each beat, doubled and redoubled repeatedly; in Western music, this is a "triplet.")
2. **Catusra gati**: 2:1 4:1 8:1 16:1 etc. (two subdivisions, double/redouble)
3. **Khanda gati**: 5:1 10:1 20:1 etc.
4. **Misra gati**: 7:1 14:1 28:1 etc.
5. **Sankirna gati**: 9:1 18:1 etc.

Gati are practiced at increasing speeds (*kala*) within each mathematical ratio.

Here the reader will begin to count the Indian way, with tisra eka tala, in *catusra gati*—a tala of three beats (*tisra eka*), with each beat then subdivided into two parts (*catusra gati*) and the kala (speed) doubled and then redoubled. First, to get accustomed to simultaneous pulses or speeds, with both palms down on a table, very slowly tap out the tala—the constant beats, represented by black circles—in unison. Now, with your dominant hand, double the speed of the tala while keeping the tala speed constant in the other hand. Once you have achieved this with ease, redouble the speed of the dominant hand. These mathematical increases are called kala.

Next, chant the counting sounds—"ta ki ta"—at the first speed, clapping the dominant hand down onto the palm of the other hand on "ta"; then, in succession, tap the palm with the little finger, then the "ring finger," keeping the pulse slow. These gestures L f f—clap and two-finger counts—will retain the constant tempo. After you feel comfortable repeating the gestures at the first speed, continue the hand gestures at that speed and double the speed of your chant—two sounds per gesture.

Finally, redouble the verbal count while retaining the consistent tempo of the hand gestures. Eventually, you will realize that the verbal sounds keep moving forward through the pulses, with two sets of voice count at the double speed and three sets of voice count at the triple speed for every clapped pulse of three. This is only a beginning step in the comprehension of the tala system.

Next, continue to practice the exercise to develop your understanding of simultaneous grouping both physically and verbally. In the chart on the following page, the first line shows the time (tala) framework, represented by counts. In the example, tisra eka tala, there are three (tisra) beats per unit. The subdivisions of the tala are duple, called eka. The speed increase is a mathematical one, so the initial pulse does not get faster. Doubling the speed and then redoubling it is indicated in line one, showing the four counts with black dots that indicate the subdivisions at their fastest speed, while the dots in the third line show the intersection of the second speed just below it. Once again, begin by gesturing the laghu at an even rate of speed; then vocalize the three sounds simultaneously at that first speed. Again, keeping the gesturing cycle at that same pace, double the speed of your vocalization so that you chant two patterns per one

laghu. Then, double the vocal speed once more to the third speed so that you verbalize a syllable at every interval represented by the top line— "ta ki ta" four times with no pauses = one set of gestured laghu at the original tempo. The third speed is equivalent to sixteenth notes in the Western system, if the quarter note is equal to one beat of tala speed. The accent created by the clap as you double and redouble the speed shifts from "on the beat," where the sounds start as you are clapping, to the third speed, where only the first "ta" coincides with a beat. Once you get comfortable verbalizing this third speed, continue clapping, and only verbalize the initial "ta" to feel the rhythmic tension this sets up. This same principle applies to the dancer's foot rhythms in relation to the drummer or both of them in unison in relation to the other instruments. This is particularly integrated into Kathak dance, where both drummer and dancer can echo or improvise upon the other's musical voices.

Tisra eka tala; tisra jati counting threes: chant "ta ki ta".

1 • • • 2 • • • 3 • • •	(Dots indicate subdivisions of the pulse into four parts)
L f f	(laghu, first speed)
Ta • ki • ta •	(chanting the Tala speed)
Ta ki ta Ta ki ta	(second speed, "doubled")
Ta ki ta Ta ki ta Ta ki ta Ta ki ta	(speed 3, tala redoubled)
1 2 3	(Tala count/clap underlined)

INDIAN DANCE LEXICON

India's classical dance lexicon requires the dancer to be emotionally expressive and physically adroit, as well as highly rhythmic. Two well-known classical dance styles are solo forms: Bharata natyam, of Carnatic origins in Southeast India, and kathak, a northern style influenced by the Mogul invasions. The third, kathakali, presents dramatic dance by dancing actors who do not speak but gesture in meaningful hand symbols, or *hastas*. All three bear close resemblance to the forms described in the *Bharata Natya Sastra*. The title of this ancient text roughly translates as "Danced Stories by Bharata." These theatrical texts were written down by the sage Bharata in the second century A.D., after Brahma, the

Creator, revealed them to him. Dancer and author Ragini Devi describes the *Natya Sastra* as defining "drama, comprising speech, mime, dance, and music," which "contains instructions drawn from ancient sources of knowledge that no longer exist."[26]

The emphasis on tala—time—in the classical Indian dance forms is immediately clear in the training, where the exercises begin with foot slaps, or *tattu adavu*. This basic action is performed in three speeds; doubling and redoubling the speed of the original tempo. In Bharata natyam, the other requirement of this exercise is to rotate the legs out and bend the three joints, lowering the pelvis as far as the resilience of the thighs will allow.

The tattu adavu, while not identical in the various forms, are learned by memorizing physical patterns vocalized in syllables called *sollukatu* that are chanted by the guru. In Bharata natyam, these begin with the action *tai*, a slap of the flat foot directly under the hip and then lifting the foot directly toward the hip without changing the level of the pelvis.

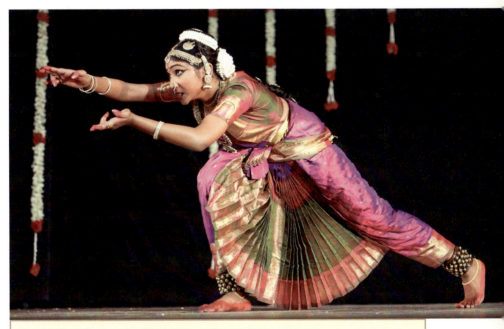

An Indian dancer in Chennai performs Bharata natyam, a traditional female solo dance form. The dancer performs complex rhythmic accompaniment to music while lifting her bare feet directly up toward her pelvis in spokelike paths, and then percussively striking the surface of the floor.

Lessons are conducted with the guru's claps, and verbal cues provide the rhythmic framework.

For example, later in the progression of exercises, an even-rhythm foot pattern, chanted "tai yum da ta, tai yum ta ha," accompanies eight weight-changing actions of the legs. On *tai*, the right leg is extended forward, placing the dancer's weight temporarily on the heel. On *yum*, the left leg, which has lifted up in place, steps back onto the same spot. On *da*, the right leg steps into place beside the left, immediately lifting the left foot. On *ta*, the left foot is placed again beside the right. Next, the dancer steps out to her right side, again onto the right heel on *tai*, but this time followed on *yum* by the left stepping in place to its original location on the flat foot, and again the right and left foot step sequentially in place on *ta* and *ha*. This sequence is repeated, initiated by the left leg. A sample of the use of this training language can be observed in the videotape *Dances of India: Learning Bharata Natyam.*[27] The narrator chants the syllables offscreen as her image performs the actions.

The second clue to the central role of time and complex rhythms in Indian dance forms is seen in performance, where the drummer is at the heart of the musical ensemble, even though the types of drum differ, depending on the regional style of these three classic forms. These include a double-headed barrel drum, a *mridangam*, played horizontally by a seated musician for Bharata natyam; *chendai*, another double-headed barrel drum that stands upright and is hit with two curved sticks on one drumhead for Kathakali performance; and a side-by-side pair of single-headed drums called *tabla*, used for kathak dance percussion.

BHARATA NATYAM: MUSIC AND MOVEMENT

The musical voices that accompany the dance forms also include melodic instruments. In southern India, a flute and a solo voice provide melody, along with a *vina*, a drone (unvarying tone) instrument that contributes constant sound by someone continuously stroking its strings. In Bharata natyam, the *nattuvanar* (dance teacher) is the chief musician and conductor of the musical ensemble for dance performance, singing the melody and playing small finger cymbals paralleling the mridangam.

In addition to foot rhythms, one of the most familiar aspects of Bharata natyam is its *mudras*, the expressive hand gestures from Hindu iconography called hastas in the genre of dance. These gestures represent plants, animals, deities, objects, buildings, moons, rivers, and a variety of other elements in the content of the dance. Many of these hand shapes are imitative of the object, which, with a little imagination, can be recognized in the gesture. Others are symbolic and require more familiarity with Indian culture to interpret.

Karanas are body postures that include centered samabhanga and abhanga; off-centered atibhanga (a great bend to one side with knees bent); and tribhanga, the thrice-broken line of the spine shown by bends to the opposite side in neck, ribs, and pelvis. The tribhanga is considered the most aesthetically pleasing of the three.[28]

Bharata natyam, kathak, and kathakali performances are intended to evoke subconscious participation in the drama through the use of *abhinaya*: the combination of verbal, facial, and gestural expression, bodily movements, interpretation of moods (*bhavas*), decorative effect, and rhythmic tension in the dance. In the *Natya Sastra*, the sage Bharata was very specific about the types of movement for each part of the body—eyeballs, eyelids, lips, nostrils, cheeks, forehead, etc.—that could express one of the eight sentiments.[29]

In a full program, three styles of performance are layered throughout the musical selections. *Nritta* is dance as pure movement, to be enjoyed for its own beauty of action, with emphasis on form, style, and qualities such as speed, weight, range, and pattern. *Nritya* is expressive dance, emphasizing motion and rhythm along with words to reflect emotions and sentiments. *Natya* includes storytelling through dramatic gesture and song, with less attention to rhythmic passages and emphasis on the emotion of the words of the singer. This was the domain of performance for which the *devadasi*-trained Balasaraswati was highly revered.

In Bharata natyam, the focus in a set of composition shifts from the abstract actions in nritta to the interpretive and expressive mime and gesture (abhinaya) of nritya. The themes may be developed around bhakti (religious devotion); romantic tales; or virtuosic, abstract movement. This last style features the complexities of rhythmic accent and progression: body actions that tilt the torso off-center to the sides or

(continues on page 48)

CHANDRALEKHA: A CONTROVERSIAL FIGURE IN INDIAN DANCE

One of the most creative and controversial Indian dancers of the modern era, Chandralekha Prabhudas Patel, was born in the town of Wada, in the state of Maharashtra, India, on December 6, 1929. After dropping out of law school in Mumbai, she moved to Chennai in 1949 to study South Indian dance, specifically Bharata natyam. Though she studied under Ellappa Pillai, a well-known dancer/choreographer, her biggest influence was Balasaraswati, whom many consider to be the last great devadasi in India.

Chandralekha made her dance debut in 1952 and continued her solo career through the early 1960s. She became a controversial figure because her productions were "celebrations of the human body,"* and because she challenged the norm of paying homage to the gods. She did away with the opening prayer session that was traditionally a part of Indian dance programs; instead, she emphasized the human aspect of the dance. In choosing to go this route, Chandralekha became a target of the Indian government, which regarded dance as a representation of religiosity. Conversely, Chandralekha emphasized humanist issues in her performances and thus became a champion of equality, human rights, women's rights, and the environment, among other causes.

In the early 1970s, she established Mandala, a dance center in Elliot's Beach in Chennai. Though the style she taught was based on Bharata natyam, her methods incorporated yoga and kalarippayattu, a Dravidian martial art from Kerala. This caused her to be shunned by Indian dance

purists but exalted by the international dance community. Although she was sometimes compared to Martha Graham for her originality, Chandralekha rejected the concept that she was simply a part of the modern dance movement of the time. She professed that she was "more faithful to the ideals of Indian art and aesthetics"[*] than to those who embraced modern dance.

Eventually, the rigidity of Indian society caused her to turn inward for a couple of decades, during which she focused on writing and graphic design, but she stayed involved in social causes. By the early 1980s, she reemerged on the dance scene and in 1984 presented a *tillana*, a southern Indian dance, at the East-West Dance Encounter in Mumbai. During the next several years, she produced many dance scores that emphasized the "indivisibility of sexuality, sensuality, and spirituality,"[*] including *Lilavati*, *Prana*, *Sri*, *Yantra*, *Mahakal*, *Raga*, *Sloka*, and *Sharira*. But perhaps her most famous production was *Angika*, which "rejected the decoration and narrative of Bharata natyam and offered new directions in Indian contemporary dance."[**]

Throughout the balance of the 1980s and 1990s, Chandralekha toured extensively throughout the world, including trips to Chicago and New York City. In addition, she won several awards, including Italy's Gaia Award for cultural ecology, Great Britain's Dance Umbrella Award, and accolades from Natak Akademi, India's national academy of music, dance, and drama. Chandralekha died on December 30, 2006, in Chennai.

[*] Reginald Massey, "Chandralekha: Controversial Indian Dancer Whose Ideas Challenged Convention," *The Guardian*, February 9, 2007, available online at *http://www.guardian.co.uk/news/2007/feb/09/guardianobituaries.india*
[**] Debra Craine and Judith Mackrell, *The Oxford Dictionary of Dance* (New York: Oxford University Press, 2000), 98.

(continued from page 45)
forward and arm gestures that reach out around the torso in sweeping arcs or jut out in spokelike pathways from the center of the chest.[30]

In the sixth through ninth centuries, a religious transformation called the Bhakti movement swept through the Tamil Nadu region (the heart of where Bharata natyam originated), which emphasized passionate devotion to a personal deity—Vishnu or Shiva. Throughout the region, creative energies focused on producing new expressions of bhakti. The devadasis became an institution in temple ritual that supported the practice of dancing its praises to the deities.

KATHAK DANCE

Kathak, like Bharata natyam, is typically and traditionally a solo performance form that developed during the period when Muslim conquerors became the rulers of India. For 400 years (the sixteenth through nineteenth centuries), the dance, then referred to as *nautch*, was developed for its sensual appeal, resulting in a reputation for vulgarity. As Kathak began developing from the bases of nautch, two schools evolved. The *Lucknow* school developed a vocabulary of expressive songs and mime, while the *Jaipur* school focused on "ornamental dance and rhythmic jugglery."[31]

The combination of expression and ornamentation has crystallized in contemporary Kathak performance, which alternates romantic storytelling and mime with spectacular and long, complex rhythmic foot patterns, made audible by anklets of 150 bells on each foot. Meanwhile, crisp, flashing arm gestures accent the foot rhythms. Closing sections of phrases feature sudden spins (at least three), abruptly halted in a dramatic flared twist of the performer's bell-shaped skirt (a short extension of the jacket for males; a full-length skirt with ankle-length pants worn underneath for female performers).

The most exciting sections of Kathak involve exchanges of long rhythmic patterns between the tabla player and the dancer, in which the accuracy and brilliance of each is a focal point for devoted fans.

In Kathak, Abhinaya are items of sung love poetry, mimed by the dancer, in which lines are repeated and varied through improvisation. Frequently, the dancer is seated during these sections. The subjects of the poetry concern Lord Krishna and his romantic adventures (with the

Much like Bharata natyam, Kathak is traditionally a female solo dance. It emphasizes physical and poetic beauty, along with sensuousness, and originated in northern India. Here, two students of the famous Kathak guru Rohini Bhate perform the dance.

dancer cast in the role of Krishna's unhappy lover).[32] This, too, is a metaphor for bhakti devotees—the longing for union with the divine is the general theme represented by Krishna and the gopis as well as Krishna and Radha.

KATHAKALI: DRAMA DANCE OF KERALA

The region of Kerala is a long, green, narrow strip of land on the western side of southern India. Trading has been going on between Kerala and such faraway places as Rome and Imperial China for several thousand years. The spice trade brought many European merchants there between the sixteenth and eighteenth centuries. It has long been a region of tolerance for differences of culture and beliefs.

Kerala has also had a long tradition of dance and dance drama, the most revered of which is a natya form, Kathakali. Beginning at the close of the sixteenth century, it developed from the dramatic form called *Kutiyattam*, which provided the only contemporary link to the ancient Sanskrit dramas of India recorded in the *Natya Sastra* and was still being performed in the mid-twentieth century in Kerala.[33]

The appearance and sound of Kathakali is bizarre and attention-getting. Heavily painted faces, with rice paper attachments at the jawline and bulbous noses, perspire under huge, weighty headdresses. The hours-long process of creating the makeup is the work of makeup specialists, who apply the thick makeup while the actor is lying supine. The colors of face, costume, and headdress are those of ancient deities, humans, and demons: vivid sky-blues, shocking limes, bright yellows, and hot reds. Long silver fingernails are attached to the left hand of demonic creatures. Most wear white, others gold or other-colored hoopskirts, flared out with the insertion of small cushions tied at the waist. Blue and red stripes are ringed around the skirt bottoms. A full-sleeved heavy jacket is worn, with lots of jewelry dangling. Long, crinkled, white cloth strips with striped, bell-shaped cuffs are draped from the neck and fly around the body as the performers move or dance. Many dancers support global headdresses at least twice as tall as their heads, in distinctive shapes that tell knowledgeable audience members who they are—demon, deity, warrior, or king.

They perform barefoot (as do most dancers of India) but frequently walk or dance on the outside part of their feet, lifting the foot up with the sole still facing the midline of the body. This takes many hours of practice during their training but bears resemblance to a strengthening use and shape of the foot that anyone in a tropical climate might develop

if he or she harvests bananas, coconuts, or other usable parts of palm trees—sickling the ankle and using the sole of the foot to grip and push himself upward as well as downward. Here one can clearly observe the connection between subsistence patterns and dance movement referred to in Chapter 1.

A reading of the *Mahabharata* and the *Ramayana* will remind or introduce the playgoer unfamiliar with kathakali to many of these larger-than-life characters. Rama was Vishnu's seventh incarnation, brought to earth to destroy Ravana, the 10-headed Rakshasa demon king of Lanka (Sri Lanka). Krishna became the eighth incarnation, whose purpose was to kill the son of a demon but is much more familiar as the blue-headed god who dallied with the gopis and later served as Arjuna's charioteer in the Bharata War.

The *JVC Video Anthology of World Music and Dance* features a kathakali rendition of this scene from the *Mahabharata*, in which Krishna reveals his true identity and urges Arjuna on to defeat the enemy. This scene contains acting, with Krishna using mudras to communicate with Arjuna; dance, in the revelation of Krishna's identity; and mime to unfold the culmination of this episode, in which Krishna whips the horses into action and Arjuna shoots his enemies with his bow as they circle and exit the kathakali playing area.[34]

THE FUNCTIONS OF MUSIC IN INDIAN DANCE

Keeping time (tala) and uniting the participants is a basic need provided by music. Rhythm is of paramount interest in Indian music; listeners keep track of musical elements by using finger and hand gestures to physicalize the structure of the music.

Melody provides mood and, in the case of Indian music, indicates time of day, temperature, and season through the tonality of its ragas (similar to the West's keys, major or minor modes). At music concerts and on occasion at dance recitals, one can see listeners using their hands in a system devised to keep track of the form of time specific to a piece of music.

3

Dance in Southeast Asia

Traditional Indian dance predominantly featured the superhuman beings that were the mythological center of Hindu civilization. In addition to the emotional appeal of these dramatic figures, the art also appealed to the intellect and the senses through its complex musical mathematics and symbolic manipulation of hand, face, and body gestures. As Indian travelers moved east, they spread their writing system along with the Brahman faith.

In the fifth century, these adoptions were described in the state of Funan, now Cambodia, and by A.D. 450, Indian influence had spread to areas of what is now Vietnam, Malaya, and Java. By the tenth century, Buddhism had also made its way to every kingdom of Southeast Asia. As author James Brandon notes, none of this had come about because of military force initiated by India.[35] No pilgrimages were purposefully dispatched to establish Indian colonies in Southeast Asia, but Indians did serve as kings in some Southeast Asian states.

Indian travelers possessed knowledge of rice growing, astronomy, mathematics, art, and writing, which made them influential and valuable as teachers. Imported Indian deities—Vishnu, Shiva, and Buddha, or heroic incarnations such as Rama—also became sources of spiritual

power that resonated with local belief systems. *Borobudur*, a mountain of statues and reliefs of Buddha and his life, which was carved in central Java in the ninth century, features images of dancing girls, musicians, and Hindu deities.

Present in almost all of the Southeast Asian cultures was some aspect of *animism*, a belief theory that was studied and first written about by anthropologist Sir Edward Tylor in 1874.[36] His work *Primitive Culture* describes the concept of soul that emerged in tribal societies: a belief in spirit beings, separate from matter, that are thought to animate nature. This animating life force is in objects as well as plants and animals (including humans). Spirit, in its separate state, can travel, as well as return to life as we know it on Earth from generation to generation.

In Southeast Asia—Cambodia, Thailand, Burma, Vietnam, Indonesia, etc.—such active, lively involvement with spirits on a daily basis led (and can still lead) to a rich array of ceremonial ways of dealing with the world of the superhumans, or gods, as well as recently transient souls of relatives. These rites involve music, dance, and dramatic expressive acts that verify the truth of each culture's beliefs. The worship of spirits (*phi*) is still an active and visibly present custom today in Thailand, where most homes have miniature outdoor spirit houses that are given reverence through daily gifts of flowers, food, and incense.

Ancestor worship also became a significant part of animistic beliefs. In a culture that identified the soul as transient, the Hindu concept of reincarnation was easily accommodated. In Southeast Asia, this animistic ancestor worship, with its belief that souls return as new family members, fit into the Hindu cosmology as activity of the Wheel of Samsara, or the Cycle of Existence, by which souls travel between incarnations here on Earth.

In Bali, the spirits of animals (pig, chicken, hobbyhorse), inanimate objects (pot lid), or other natural phenomena (wind, rocks, trees, illness) can also enter the human body, sometimes for malevolent purposes. Sacred spirits (local deities, including Barong, a lionlike being) may also take over the personality. A "possession" generally has a specific function, such as healing in response for favors. Possession may also be the spirit's way of communicating its desires for a new template, better offerings, or proper behavior of humans. Dance movement, such as *Sanghyang Deling*, with its recognizable, anticipated aesthetic characteristics

("*deling*" = puppet movement), provides impressive verification of the presence of these various spirits and can be recognized as one of Melford Spiro's "connectors" to the superhuman realm.

In what is now Thailand, episodes from the *Mahabharata* and *Ramayana* became the subject of drama and dance. Reenacting military or intellectual triumphs was a means of empowering the king to achieve equal success. Identifying himself as one of these powerful gods, and having likenesses of the god carved with his own features, the king absorbed the deity's power and made himself the essence of the state as well. This started a dynasty in Thailand, where, in 1782, General Chakri took the name Rama I and declared the *Ramakien* (the Thai-adapted version of the *Ramayana*) to be the national epic of Thailand. Rama I's substantial harem of wives and concubines became the cast of characters who performed this ritual drama in his honor.

Because of this custom, traditional Thai court dance was originally performed separately by either male or female dancers. Much of the movement was adapted from the Angkor civilization's (located in present-day Cambodia) *Khmer* dance due to a long-lasting power struggle between the two civilizations over several centuries. Ritual dances of the Khmer assisted with ancestor communication and fertility rites. In particular, the *apsara* dance, which presented the dancer in celestial form as a heavenly nymph or angel, was celebrated in the sculptured dance poses at Angkor Wat, Cambodia's stone monument. Over several centuries, starting in 1431, when Thailand conquered Angkor, dance troupes were captured and moved between the two regions as spoils of war.

In the contemporary period, most of the cultures of Southeast Asia have retained, or, in some cases, restored their performing arts to provide a link to the past, attract visitors to improve their economy, or continue an essential role within the local culture. This is particularly true where the performing arts remain associated with the belief system, as in Bali, where many dance performances are required to attract and entertain the gods in temple festivals that celebrate the harvest and reinforce religious and cultural needs. It has become an economic plus in twentieth/twenty-first-century Indonesia that Bali's proliferation of dance forms also attracts a large tourist population, intrigued by the variety and dynamism of the style.

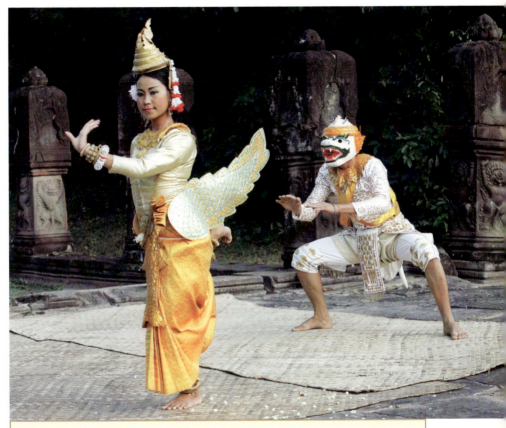

The Khmer dance originated with the Angkor civilization of present-day Cambodia and played a large role in influencing Thai court dance. Here, two classical Khmer dancers perform in Cambodia.

THAILAND'S CLASSICAL DANCE TODAY

The College of Dramatic Arts in Bangkok, Thailand's capital, is a major center for the training of contemporary performers of Thai classical dance. The style requires unusual flexibility in hyperextension of the elbows, hands, and fingers (and gradual but extreme stretching to attain it). Role types related to physique and temperament are assigned to students when they begin studying classical dance. Heroes and heroines are assigned to learn a long vocabulary of movements to music, while demons and monkeys (who must be tall or short, respectively) study sets

of shorter dances that emphasize postures and acrobatic actions. Heroes may be played either by a male or female dancer of the heroic category. Only males play the demon or monkey role.

Males in the demon/monkey role must attain maximum flexibility and strength in the hip and thigh to maintain as close to 180 degrees between the knees in the open, bent-legged position typical of these roles (an extreme "second position plie" in the ballet idiom of the West). At the same time, hyperflexion of the knee of both the supporting and gesturing leg creates a sense of groundedness. The movement vocabulary for demons and monkeys emphasizes martial arts, acrobatics, aggressive behavior, and strength.

Heroes and heroines both walk with light steps, toes lifted off the floor. Female performers take the apsara position, both standing and at floor level on the knee, where the raised lower leg is flexed to an acute angle so that the foot is lifted almost to buttock height.[37] Wrists, elbows, and fingers are stretched and pressed into hyperextension during training, producing a flowing curve that is as attention-getting as

Students perform in a dance class at the College of Dramatic Arts in Thailand's capital, Bangkok. The students put on many shows for the public and help to increase awareness, understanding, and appreciation of Thai classical dance.

Western ballet's rise onto the tips of the toes, with the gesturing leg thrust high into the air.

Although Thai dance patterns have their origins in Indian dance, the elaborate array of India's meaningful hand gestures, which referred to common characteristics of the Hindu deities who were the subjects of the dances, were almost completely eliminated or altered by the Thai. The elaborate symbolism of mudras was replaced by dramatic imitation, or pantomime.[38]

Expressive eye movements are also not present in the placid, dignified elegance of Thai dancing. In Bali, however, indigenous dances employ more dramatic animation than the other Southeast Asian dance forms, with an active role for the eyes in choreographic and dramatic movement. Bali also retains more Hindu traits embedded in its culture than have other parts of Indonesia, where Islam dominates.

One of the most dramatic, spectacular, and monumental of performance styles is the classical Thai dance drama, the *khon*, which is credited to Rama II (king of Thailand from 1809 to 1824), who emphasized its performance techniques and added more classical dance. Originally performed outdoors, the khon developed into a lengthy event with spectacular battle scenes and victory scenes capped by the winner posing on the thigh above the unworthy loser. This pose frequently resembles a scene such as those found in Angkor reliefs.

Lakhon is another type of dance-drama form that draws primarily on plots from other sources than the *Ramakien*, such as *Jataka* stories (based on Buddha) and other local folktales. A popular example of this type is about *Manora*, a supernatural creature called a "kinnari," who is both bird and human. She is captured by a hunter while bathing and carried away to a palace, where she marries a prince who immediately goes off to battle. After a close call with death, in which she is burnt on a pyre, she recovers her wings and flies home. There, at long last, the prince obtains some magic and finally is reunited with Manora.

The costume for many of these styles includes the golden helmet that is a signature of Thai dancing, with a pointed spire that resembles the shape of Thai temples. Typical of the costume is a wrapped leg pant and pointed, curved shoulder extensions that also resemble Thai architecture, with upturned points that arc up to ear level.

(continues on page 60)

KHON: THAI DANCE DRAMA

Among Thailand's most famous classical dances is khon, a masked dance drama developed during the Ayudhaya period (c. A.D. 1600–1700). The dance is based on Thai martial arts, and the stories that are performed come from the *Ramakien*, Thailand's national epic based on India's *Ramayana*. Each performance pits good against evil, with Phra Ram (Rama), the good king of Ayudhaya, defeating Thosakan, the bad king of Longka, in the end. Khon is based on the *chak nak dukdamban* ritual, which was originally performed during the Indraphisek ceremony. This tradition took place at the coronation of the new king of Siam (now Thailand) by the Hindu god Indra. During the ritual, military officers and civil officials dressed up as demons, monkeys, and gods from Hindu mythology and participated in a tug-of-war, which recreated the myth of the serpent king Ananta Nakharat.

Performers of khon learn the dance from a very young age, typically starting by 8 or 10. Training usually lasts for 9 to 10 years, and performers are assigned to be one of four characters from the *Ramakien*, based on their physical appearance and talents. They learn basic dance movements known as *mae tha*, or mother movements, while also learning martial arts for the fighting scenes. Among the major types of khon are *khon klang plaeng*, which is performed in a large field; *khon rong nok*, which is performed on an open stage; *khon na cho*, which is performed in front of a screen; *khon rong nai*, which is a maskless dance drama; and *khon chak*, which is performed in a theater with a painted backdrop.

Khon performances open with *Chap Ling Hua Kham*, or "Catching the Monkeys in the Early Evening". This is a prelude to the main performance, which tells the tale of a hermit and his two monkey disciples. Next, the main

performance begins, where the overarching theme of good against evil takes center stage. The protagonists—Phra Ram and Thosakan—are compared and contrasted through their

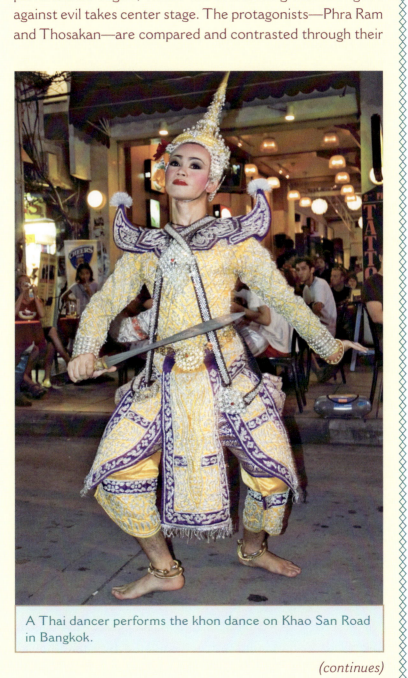

A Thai dancer performs the khon dance on Khao San Road in Bangkok.

(continues)

(continued)

personalities and political and social views in order to provide the audience with a lesson of what is and is not good. Throughout the performance, demons, monkeys, soldiers, and court jesters are used to offer comic relief from the main point of the story.

Musical accompaniment is important in khon. The orchestra, which is composed of two wooden xylophones (*ranad*), an oboe (*pi*), circular gongs (*khong wong*), two small cymbals (*ching*), and two tympani (*klong*), is used to create music that portrays actions such as fighting, flying, marching, sleeping, and walking. In addition, narrators (*khon phak*) supplement the music by contributing the dialogue for the other characters through the use of poetic rhyme.

Though khon was used for a time as a way to revive the martial arts tradition of Thailand and to promote the political policies of King Vajiravudh in the early 1900s, today it is a way for the people of Thailand to preserve their culture. Among its most impassioned supporters in recent years was Mom Ratchawong Kukrit Pramoj, who served as prime minister of Thailand from 1974–1975. A trained khon dancer, Pramoj created the Thammasat University khon Troupe, which has been used as a tool to train aspiring politicians in the ways of traditional Thai culture. Thanks to the work of Pramoj and others, khon training is popular in many Thai schools, colleges, and universities and remains an important part of the nation's heritage.

(continued from page 41)

The orchestra, called *pipad*, which accompanies Thai dancing, is an ensemble typical of Southeast Asia in that it is primarily made up of percussion instruments that include drums, xylophones, and other metalophones.

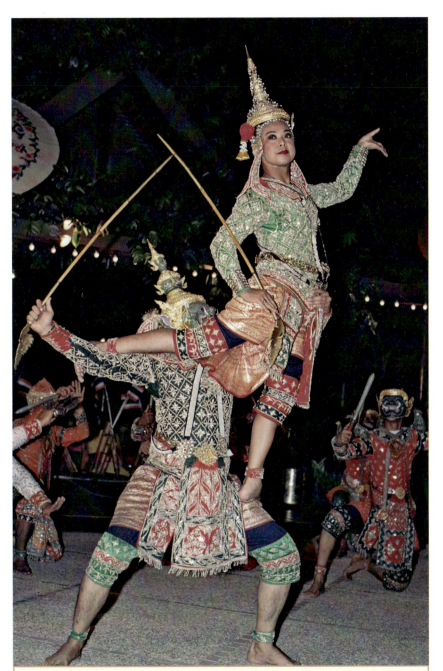

Like the khon dance, lakhon is a dance drama based on stories from Thailand's rich history. Unlike khon, lakhon moves beyond the *Ramakien* and includes a wide array of stories from Thai folktales and the Jataka tales—stories of the Buddha's previous births.

4

The Famous Dance Cultures of Indonesia

Prior to the fourteenth century, Java was both a Hindu and Buddhist culture. In the eighth and ninth centuries, two ruling dynasties, the Sailendra (who were Mahayana Buddhist) and the Hindu Sanjaya dominated the central region of Java. Two huge constructions were commissioned at this time: The Sailendra carved out Borobudur, while the Sanjaya erected Prambanan, which has eight major Hindu temples, dominated by a tower honoring Shiva and surrounded by 156 shrines. Both are still standing, and they provide a sculptural history of Indian dance, as well as portray musical traditions that have grown in Java. One can see the *gamelan* (the orchestra of bronze instruments of present-day Java and Bali) alongside the poses and actions of Indian dancers. There is evidence that shadow puppetry and dance techniques of India were melded into the court traditions of the region as well.

Power shifted to East Java in the tenth century and the monumental Indian constructions were abandoned. The Majapahit dynasty, which was at its height from 1275 to 1477 A.D., became the last Hindu power in Java and took Bali under its control. Islam spread from the Malay Peninsula into Java, and after a short time, the Majapahit dynasty collapsed and Islam took power in the early sixteenth century. A large contingent

of Hindu-Buddhist Javanese departed Java for the small neighboring is-
land of Bali, which they had claimed earlier.

Central Java rose again in the seventeenth century under Agung, a
sultan in Yogyakarta (present-day Java's cultural capital) with a sumptu-
ous court. Dances, which can still be seen today, such as the *bedhaya*
and *srimpi*, were videotaped for the series *Dancing*, which appeared on
American television in 1992. In the bedhaya, a slow, meditative dance,
nine females dressed in identical batik *sarongs*, which form the skirt of
their costumes, progress barefooted into the *kraton* (sultan's palace),
their black velveteen vests cinched tightly. A flowing batik panel drapes
from the gold belt at each waist. On their heads are gold crowns with a
lightly floating feather hovering above each.

With each step, the toes are raised and the weight gradually pressed
onto the foot from the heel. A remnant of Indian cosmological symbol-
ism is suggested—the nine dancers might be the eight cardinal points,
together with the center of the universe. Another concept is that they
represent the nine human orifices and thus stand for the human body. In
keeping with other philosophical concepts of Javanese court dance, they
might represent the struggle between the human mind and desires.

Whatever they represent, the sustained, in unison quality of
stretched time and minimal differences can easily mesmerize the viewer
into a philosophical state of mind and body, which is one of the desired
effects of this ritual on the participant.

In a srimpi dance, in the Yogyakarta kraton, women also engage
in stylized fighting with small daggers. In imitation of the puppet-style
performance—*golek*—a female duo depicts a battle between princesses.
They rotate their thighs out, opening their knees and pressing down into
deeply bent legs, as they prepare to attack each other with their daggers.

Counterbalancing this philosophical blend of movement and medi-
tation is the male court dance of Yogyakarta, *wayang topeng*, or masked
theater-dance. Three traditional sources of the subjects are the *Mahabhara-
ta*, the *Ramayana*, and a cycle of stories from the Majapahit dynasty, *The
Adventures of Prince Panji*. Seldom are topengs performed in full length.
Generally, single dances, dramatic in nature and frequently concerning
love, love in vain, or love lost, are the subjects of these performances.
Characters are traditionally defined as noble, refined, and strong.

Wayang topeng is a dance drama that was inherited by the court
of Surakarta along with the bedhaya dance in 1775, when the kingdom

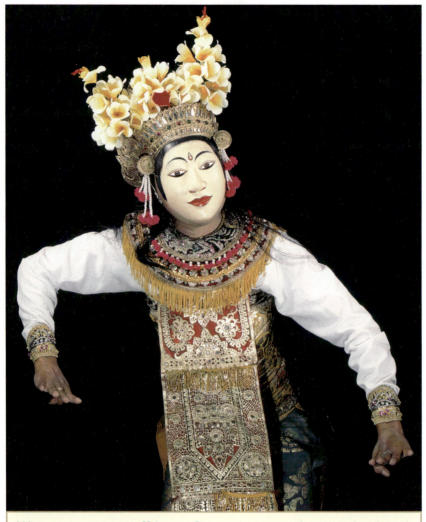

Wayang wong is an offshoot of wayang topeng that was developed by Yogyakarta's sultan in the late 1700s. Here, a Balinese dancer performs this two-dimensional dance, moving parallel to an imaginary screen, much like a puppet.

split in two. Subsequently, Yogyakarta's sultan created a new form, the *wayang wong*, in the style of Majapahit tradition, designing it in the spirit of *wayang kulit*—the puppet shadow theater. The action of the actors is two-dimensional, moving as the puppets do, parallel to the imaginary screen.

There are four basic hand positions in wayong wong, recognizable from the current study of Bharata natyam. But in wayong wong, the gestures

are decorative rather than communicative—as they are in the present-day South Indian form. Because the sultan was associated with the Hindu god Vishnu, the plots revolved around him, and the performance was timed in relation with the sun's appearance, because Vishnu was related to the sun.[39] A large palace gamelan orchestra accompanies the performance.

The male and female performers of Java's kraton dances display highly defined stereotypes: the refined, strong female, with a body and style that is related to their role type. "Withheld strength" is the stereotype of the Javanese hero, whereas a strong male type moves with "aggressive masculinity."

Dance and drama preserve past images of role models from a worldview no longer encompassed by the religious beliefs of the Islamic Javanese. But, as previously noted, late twentieth-century Indonesian court dance performers, such as Ben Suharto, apply concepts introduced from contemporary practices of Islam, integrating traditional performance practice with current belief systems. Thus, the revered "old" is made new again and regains its vitality for current generations.

THE ARTS IN BALI: WORLDVIEW, RELIGION, AND PERFORMANCE

Traditional life on Bali exists in a spiritual context that emanates from the physical structure of the island itself. Traveling up or down its valleys, from the surrounding waters of the Bali Sea and the Indian Ocean to the peaks of the holy Gunung Agung (Mount Agung), is a journey of geographically charged directions. Downward and away from the mountain is known as kelod, while kaja means up; traveling toward Agung and the sky above it. Brahma, the creator, dwells in the realm above the island, along with the *dewa*, Balinese gods whose origins are Hindu-Buddhist and ancestral. These powerful forces descend from the sky, moving in the kelod direction toward Besakih, the Mother Temple on Agung, to be entertained and honored by humans who welcome them.

For the Balinese, moving in the kelod direction is to progress toward the ocean, which is also the realm of the *buta*, a word that means both "elements," the substances of which the physical world is composed, and "demons," who require attention to prevent them from harming

the Balinese. The worlds of dewa, humans, and buta require structures, events, and continual human attention to keep the whole in balance.

Time, location, direction, and language have complex relationships in the flow of life, which strongly and constantly affect human as well as godly interactions. A Balinese will not say, "go south on Denpasar Road and take a right toward Sanur." More likely it will be, "Go kelod to Denpasar Road, turn kanjin toward Sanur." *Kanjin* is Balinese for east, but for the majority of islanders it refers both to the location of Agung and the direction of sunrise for the entire island, the geographical east.

Bali is a small island in the Republic of Indonesia, 172 miles long (east to west) and 102 miles wide (north to south). In spite of its limited territory, Bali supports upwards of 20,000 local temples, where frequent festivities entice the deities to descend for their pleasure, entertainment, and favor. In each *desa* (village), three important temples are built in specific locales. The dewa temple, honoring Brahma, the Creator, is on the spiritually charged Agung side, which is always kaja of the community. Desa temples (for the middle world of earthly, human concerns) are in the village center, where Wisnu (Vishnu), the Protector, is worshipped. Kelod of each village, in the direction of the ocean, are the buta temples, associated with Siwa (Shiva), because of his destructive aspects in the life cycle and the dead. (Note: Balinese pronounce the *v* in these Indian deities' names as a *w*, and use a soft *s* for the "sh" sound.)

At specific "charged" times on local villages' ritual calendars, seasonal varieties of ceremonies, activities, and performances devoted to the dewa take place in these temples—each devised independently of other desa in both time and content—to please and involve both spirit and human audiences. They also activate cooperative power to adjust and improve human behavior. The Balinese worldview continually takes into consideration the interconnectedness essential to successful accomplishments, not only for interrelationships but also for survival.

The proper intersection of place/time/context, or *desa/kala/patra*, brings about the successful relationship of nature, gods, and humans in a Hindu-Buddhist framework unique to the Balinese with the incorporation of their ancient animistic beliefs. In Balinese village life, this requires a conjunction of effort from the community in accordance with the many intersections of power on the calendar.

A Balinese man walks toward Gunung Agung, outside of Tulamben, Bali, in Indonesia. Gunung Agung, or Mount Agung, is an active volcano and a sacred place to the Balinese.

Enactment of sacred texts in context of local situations empowers the Balinese to affect human behavior to a greater degree than occurs in the Indian Hindu performance of rasa and bhava. A single performer may speak in six different dialects of a local language to reflect the perspective of each "voice": the storyteller, the village peasant, the court noble, or a quoted source from the *lontars*, sacred texts such as the *Ramayana* or the *Mahabharata*.[40]

The temple events that unite demons, deities, and humans are both social and metaphysical and require a great deal of human effort on a regular basis to sustain. The musical, choreographic, and visual arts are combined with each household's selection of flowers and food for elaborate display, as offerings, and for consumption. These offerings of beauty and potency, along with the masks, paintings, music, dances, costumes, and dramatic performance, combine to make up *Budhaya*, or Balinese culture. Together with *Adat* (society) and *Agama* (religion), they provide the three communal binders of Bali.

Except for the regular cyclic times of these festivals, the island's temples are quiet. No replicas of the gods are on display, although

daily offerings are regularly provided. Each household maintains its own miniature towers within the walled family compound, where offerings are placed daily, including beautiful food delicacies for the buta, which are placed on the ground toward kelod. Small offering towers also sit in each family's rice fields, so Dewi Sri, the rice goddess, may be nurtured and encouraged to protect the rice crop. The physical offerings are in forms specified by Krishna, Hindu god and heroic reincarnation of Wisnu, one of the three powerful original gods of Hinduism. Each contains the colors of the Hindu Trimurti: red for Brahma, green for Wisnu, and white for Siwa.

The uniting force for Balinese survival is *Agama Tirta* (Religion of Holy Water). This medium is at the apex of magical powers and a powerful system of water management that reigns over the complex of mystical beliefs and symbols that preserve and maintain Bali's unique worldview and complicated ritual system. Water for ritual is collected at high, pure mountain springs and made holy by priests' blessings and prayers. It is carried by priests in small glass bottles for ceremonial use at temples and for the purification and blessing of people, buildings, and rice fields.

The water forces on the island come from the gods and are supportive and benign, while the ocean is the source of demonic power. Gunung Agung, which erupts at irregular intervals, spews in retribution from the dewa or buta when they are displeased by human actions. Ceremonies to appease and persuade the gods to forgive and continue to support human existence and success are organized at regular points on Bali's complex system of overlapping calendars made up of weeks of varying lengths with intersecting days of power to be respected with ceremony.

Bali indeed provides one of the most vivid examples of Clifford Geertz's definition of religion: It is Agama Tirta that establishes the "powerful, pervasive moods and motivations in humans, by formulating conceptions of a general order of existence," and carrying out the products of these conceptions through the village and temple organizations.

These uniquely realistic relationships still operate on a daily basis at the interface between the spirit world and the "middle world" (Hinduism's world of maya, the daily life humans experience), and the "upper" and "lower" worlds, where powerful spirits and the spirits of Balinese ancestors dwell between visits or lives on Earth. Dance, most of all—with the startling act of trance possession, which, as Geertz describes,

"clothes these conceptions in factuality"—provides empirical evidence that the gods have come to the middle world.

The practice of art-making, in other words, is not separated from daily life, but in fact is essential to it because it confirms the solidity of the relationship between the spirits and humans. Each world has a responsibility to the other to keep the middle world (of humans) functioning. Nowhere in Southeast Asia has this role of the arts as religious entity been such a strongly maintained, universally shared activity as in Bali. At the same time, twenty-first-century theatrical, nonspiritual versions of the same dances have been rearranged and shortened for performance in the tourist trade. These daily presentations form a significant part of the economic base for some villages.

The *pura* (temple) system provides the structure for demonstrations of the relationship among the three worlds, as well as governs the relationship between village communities and inside each village through the *banjar*, civic organizations much like American Rotary or active 20-30 clubs. In the banjar, villagers take on specific duties suitable to their particular age and capacity, as well as to fulfill certain kinship responsibilities. Water rights, the system of agricultural rotation, and duties in the banjars are all governed by one or another such pura. Each Balinese is responsible to a number of these temple-determined groups at any one time, as well as during different periods (ages) of her/his lifetime. Desa operate like very large families, with integrating relationships throughout one's social, sacred, and aesthetic aspects of life.

A temple, then, is not the dwelling place of the spirits where humans go to worship. Rather, it is like a hotel or conference center, where deities are persuaded to visit. Here, the deities receive artistic and physical pleasures for their support and concern for the Balinese in such matters as agricultural success, avoidance of illness, and protection against black magic and other threats. Out of respect for the sacred space, the Balinese remove footwear before entering a temple, and all dances, whether in sacred or secular locations, are rehearsed and performed in bare feet.

SACRED AND SECULAR DANCES

The Balinese distinguish three categories of dance, indicated by the locations of their performance within and outside Bali's three-part temples

and their origins. Earliest imports came with the Neolithic cultures of ancestor-worshippers who arrived in Bali from Southeast Asia over many centuries prior to 1000 B.C. Later importations included Hindu-Javanese elements from the region of central Java. Ongoing creation by the Balinese in ensuing centuries melded new developments with traditional forms and applied them to new functions. The dances were categorized according to their use.

Wali dances are those performed in the inner courtyard of Bali's temples. They belong to the indigenous village traditions, and are meant to entertain and please the visiting deities in order to bring good conditions to the Balinese people. Wali dances stem from the very early continental rituals and are uncomplicated in their choreography, which is symbolic or purely aesthetic movement. Villagers dress in their best batiks, decorating their hair with flowers or wearing shiny headdresses. The sequences—slow walking or marching, gesturing with a flower or weapon—can be learned and performed by any healthy Balinese, so that the villagers who dance them can focus on the offering of their performances as pleasing gifts. These dances are seldom performed for any purpose other than their supplications to the dewa. Included, however, is a personal sense of pleasure that comes from a well-achieved performance.

Wali dances referred to as Sang Hyang are performed by dancers in a state of trance, a condition that invites possession and transformation by powerful spirits of both animate and inanimate beings. Such displays of behavior provide visible proof of supernatural activity and reassert the presence of the dewa, as well as their power.

Bebali dances take place in the middle or second courtyard of the temple. They are dramatic, optional entertainment for the gods and humans, unlike the wali dances, which require the dewa's attendance. They include stories from the Hindu classics, as well as Balinese legends, and are not ritual in nature. Bebali performance in temple festivals, however, is also meant to amuse and reward the gods for their favor. Their stories and movement are sophisticated, drawing on the waves of influence from the Javanese Majapahit Empire and developed in Bali's courts over several centuries.

Bali-Balihan, secular dances that exist for entertainment but can be given as part of a religious festival in a temple, make up the third category of temple dances. Performers in this genre undergo advanced

I NYOMAN KAKUL: MASTER BALINESE DANCER

Among the most famous classical Balinese dancers is I Nyoman Kakul. Kakul was born in 1905, in the village of Batuan, Bali, and his parents were rice farmers. By the time he was a teenager, Kakul started to perform gandrung, a dance that honors the goddess of the rice paddy, Dewi Sri. He also began performing the sacred barong ngelewang as part of a traveling dance troupe.

Kakul would go on to specialize in the barong bangkal and celeng (boar and pig) masked dances, which are noted for their costumes made of woven coconut leaves and are animated by two dancers. During this early period, he also studied gambuh dance theater; the male dance baris, which he quickly mastered; and the topeng masked dance. As he moved into adulthood, Kakul initially had trouble supporting his new family. He engaged in a number of side jobs, including selling such commodities as firewood, rice, and sugarcane. Eventually, he procured a job teaching baris at the royal residences and the palace in the regencies, or districts, of Klungkung and Bangli. Over the years, his influence spread, and he taught both genders performance, dialogue, plot development, and vocal characterization, among other components of dance.

In becoming so celebrated, Kakul was in high demand throughout Bali. Consequently, he traveled near and far, spending a year or two at each village to teach his techniques. Once the village dancers mastered a technique, Kakul moved on to the next place. Kakul's dances came alive through the *jiwa*, or spirit, that was so pronounced in his troupes' performances. He became most identified with

(continues)

(continued)

topeng, having been initiated to perform priestlike functions in the mangku topeng and the solo topeng pajegan, which was accompanied by the gamelan orchestra. He also owned a sundry collection of topeng performance masks, some of which he carved himself. During his topeng performances, he would often change masks, and thus characters, which made for a provocative comic performance.

During the early 1950s, he toured the United States, Canada, England, France, and Germany with John Coast's group, the Dancers and Musicians of Peliatan. In the 1960s and 1970s, Kakul became esteemed for his instruction of foreign dance students, as well as dance teachers and students from dance academies throughout Bali and Java. He also taught for several years at KOKAR, a high school for the performing arts in Denpasar, the capital of Bali. Among his many awards is the Piagam Seni, the nation's highest artistic distinction, which is presented by the president of the Republic of Indonesia. Though I Nyoman Kakul died on August 2, 1982, his legacy is carried on by his descendents, many of whom perform with the gambuh group Sanggar Tari Nyoman Kakul, which was named in his honor.

training, having displayed talent early in their youth. The gods are fond of this genre for its beauty and the skill of its performance, but it is not devotional in nature. The presentation of refined skills adds a note of joy to the spirit of the occasion. The dances include legong, kebyar, modern baris, topeng, arja, and prembon, all of which are prominent in contemporary performance for both Balinese and tourist audiences.

In 1971, a variety of Balinese forces came together to solve a problem caused by the popularity of Balinese dancing for tourists. Travel agents sought more variety of performances and were willing to pay for them. They requested dances they saw in temple ceremonies or brought their

clients into the temples. Fearing that wali dances were being tainted by their importation into secular performance for money rather than devotion, the Balinese held a seminar to resolve the situation. The circumstances of performance in the three categories were further stipulated to prevent the exhibition of sacred dances for commercial purposes.

The wali was to remain a ritual dance that was presented in the inner part of the three-part temple space. These dances were declared to be singular in purpose, dedicated to the pleasure of the gods, with no fees to be paid for performance in secular locations. A Balinese or visitor might contribute offerings to the temple upon visiting a wali ceremony but not hire dancers to perform for secular purposes.

The committee designated the bebali category to be available for secular situations, but no money was to be paid by those requesting the performance. Although this financial prohibition has not been strictly carried out, seldom are sacred objects used in these tourist/consumer performances. The Balinese themselves request such performances for special occasions such as tooth-filing ceremonies.

The third category, Bali-Balihan—secular dances of the third courtyard originally intended for secular spaces—were specifically designated as available for payment of fees. These dances focus on entertainment for the audience and, together with the dramatic forms of bebali, take on religious significance when performed in honor of the gods as part of the sacred events of temple festivals. Their emphasis is on theatrical, aesthetic, and entertainment values. The gods enjoy such displays as much as their Balinese devotees, as well as the tourists who pay to see them in theatrical settings.

Each temple has a "birthday," the Odalan, every 210 days. During this time, the deities are invited to come down to be honored and entertained. This cycle is a locally determined one, so the date is unique to the particular pura and, consequently, not celebrated on the same day throughout Bali. Intersecting or juxtaposed calendar cycles continually call the attention of any individual to her/his responsibilities to one or another temple. Balinese who move to another area to obtain work are expected to return home for their local Odalan. Duties to be fulfilled are of many types, including temple dancing, playing music, making elaborate carvings of bamboo decorations or beautifully arranged food offerings, or merely attending the ceremonial functions to increase the honor paid to the gods for their presence.

Child musicians perform during an Odalan, or temple birthday celebration, in the village of Batuan, Bali. Odalans are held once every 210 days and include temple dancing, music playing, and making elaborate decorations or food offerings to the gods.

This cyclic structure of celebration is built on the life cycle of growth and decay. Such cycles permeate Balinese life and art. Because the stone temple sculptures are made of sandstone and deteriorate in the tropical climate, they must be recarved on a regular basis. Bamboo temple decorations dry up, to be recreated anew for each occasion. New generations must be taught the ritual dances in preparation for the visits of the gods.

PARTY FOR THE GODS

The dewa come down from the heavens during Odalan to be thanked and entertained for their protection and intervention in the Balinese's constant struggle for balance between the dark and light forces in their world. Upon arrival, they are dressed in finery—regaled with flowers—and proceed to embody the small, carved figures called *pratima*, which

are placed in portable shrines. Once these figures are carried into the innermost temple by the women of the village, they are given seats up front for the best vantage point. Later, they will be taken to bathe in a mountain stream.

In the early afternoon, village females of all ages, as many as 40 to 60 dancers, perform *rejang*, one of the most ancient ritual dances. Formal and slow in its presentation, rejang is simple and inclusive of all ages and skills. The dancers wear a gold half-moon-shaped headdress, decorated with fresh flowers. They manipulate a long sash as part of the choreography, while four long lines dance toward the pratima, waving fans as they hold their sashes in a gently draped curve. Accompanied by the older, traditional-style gamelan gongs, each row advances toward the front of the courtyard, where the gods observe and receive their performance offering and ritual demeanor from their elevated shrines.[41]

Another choice might be *pendet*, in which the women take a snake-like pathway with rapid steps as they progress into the inner courtyard. They carry a small plate with an arrangement of white flower chains draped on all sides. Elbows lifted sideways and sharply bent, the women rotate their upper arms, lifting and dropping the elbow, which moves the stretched fingers in arcing paths. Stopping, they bend deeply down, shifting hips and chest in opposing directions. Their heads shift and slide smoothly above their necks, with sudden stops that arrest action in all but their darting eyes. The sarong is tightly wrapped around the pelvis and legs, which limits the size of their steps and provides tension as they press down into their bent legs. The accompanying flutes are like humming birds or bees, their melodies winding up and down above the shimmer of the bronze resonance of the gamelan.

Gabor features four to eight pairs of trained dancers who also gesture bowls of flowers while performing an extended offering dance, which requires talent and practice for its lengthy display of various dance skills. An hour may pass before all of the bowls have been choreographically presented to the pratima.

Males offer *baris gede*, a ceremonial martial dance whose origins descend from the Majapahit dynasty. There have been many styles, but the dramatic form we see now developed after the American Civil War, when Bali was "discovered" by the West, and visitors were attracted to the island by its performance arts.

Baris means "warrior" and refers to male dances; *gede* means "great." Other dance titles follow baris to describe specific objects and sacred heirlooms, which are to be manipulated for that version, such as long spears, shields, lances, knives, or more recently, rifles. Adult males from the banjar organizations, standing in rank and file formation, manipulate the same chosen weapon, according to the occasion. During a baris katekok jago performance filmed in 1975 in the village of Sebatu, the baris dancers carried long red and white striped spear poles, with ribbons dangling from the tops.[42] However, not all male dances require weapons. Baris Pendet is danced with flower offerings like those of Gabor.

In ritual dances such as rejang and baris, the impact of the performers' dedication is more important than the choreography or its execution. The men's actions are simple and direct, with an emphasis on up and down movements of both dancers and their spearlike poles. Sustained, quietly held balances on one foot, with the other leg lifted at a right angle, test physical equilibrium and inner peace. A triangular gold headdress is decorated with a pyramid of many pointed fragments of mother-of-pearl. These are attached to springs that cause them to quiver as the dancer moves, providing an extra kinesthetic effect, heightening the sense of awareness and mystery.[43]

The baris performers chant sounds such as "hoo, hai, hai ha!" while moving the pole up and down in crisp synchrony. Imitating battle, they thrust the pole in spearlike actions. Other times, it rests on one shoulder while short bursts of quick footwork are interjected as the tempo increases. The typical male-style vest, made capelike with many colored strips of gilded brocade that dangle from both the front and back of the shoulder girdle, along with a white shirt and pants (Siwa's color) that are worn underneath, comprise the costume. Red (Brahma) and green (Wisnu) dominate in the vest.

A third category of ritual performance, Sang Hyang, involves states of trance, where performers are taken over by specific spirits or impulses in order to cleanse the village of disease or social dissonance, or to reveal a message from the spirits of their need for attention in order to avoid disaster. In these states, little girls may be carried on the shoulders of men, imitating the movement of Legong (which they have never studied), or be drawn into trance by the use of puppets.

Ketjaq, also called Caq, is a seated dance for men, who chant as monkeys in a ritual battle to free the village from some unclean condition. Ritually, this dance accompanies the Sang Hyang Dedari, drawing the girls into their altered state for the healing visitation of the spirits. But starting in the 1930s, it has also been presented in a secular version, outside the temple for tourists. This occurred when Walter Spies, an influential Western artist living in Bali, suggested that the dance be performed in conjunction with a theme from the *Ramayana*. The subject concerns the abduction and rescue of Sita by Laksmana (Rama's brother) and Hanuman, the monkey king, with his monkey troupes. Regular daytime and night performances are staged in the Bali Arts Center in Denpasar, as well as in villages in the central arts area around Ubud.

Trance also occurs outside temples, at crossroads, which are charged with dark powers and become the battleground for significant stand-offs for powerful figures such as the Barong, a lionlike creature that is performed by two men strong in devotion and ability who manipulate the large mask and body of the beast. They and their opponent, Rangda, the witch, enchant the group of warriors who then attack themselves with their sharp swords, falling to the ground in deep trance. A priest comes with holy water to revive them and bring the leading characters out of trance. Other incidents involve men taking on the characteristics of beasts: rutting like pigs, climbing trees in monkeylike fashion, or being possessed by inanimate objects such as a pot lid. The gods and demonic forces are responsible for such displays, which provide proof of their power and reality. These frightening figures and rituals cleanse the community of the influence of the dark side, which may be disrupting health or human relations.

In bebali performances of the middle courtyard, dramatic encounters based on Hindu's *Mahabharata* or *Ramayana*, as well as those with Balinese historical characters, are acted in dancelike style, with exaggerated movement and facial expressions to make them easily visible for the audience, which is traditionally seated on the ground. The topeng dance includes characters who wear stereotype, full-face masks that immediately identify them as prime ministers, elderly courtiers, and other dignitaries, who gesture their thoughts while speech is provided by their attendants. Servants and clowns wear half-masks, and can speak for themselves.

For tourist performances of the Bali-Balihan genre, small theatres with elevated stages and raked seating provide a tent or roof above. Adaptations of the temple flower-offering dances open these performances, with fresh flowers scattered into the audience as a welcome. *Panyembrama* (greeting), a Kebyar-style dance, was created by a Legong teacher in 1967 and is purely secular. In 1993, *Sekar Jagat* (Flower of the World) premiered. It was based on the sacred Rejang presented in one of the ancient villages and is far more elegant, stately, and formal in presentation.

A popular performance in village tourist venues is the "modern" baris, a dance portrait of the young warrior in the abstract, dramatically displaying his demeanor, speed of response, agility, and fierce aura. Eyes, hands, arms, and torso rise and fall, and then shift right to left in small bursts of action, underscored by skittering feet that elevate the dancer to a frozen, suspended moment. Nothing moves but his fingers, which are like hovering bees buzzing with nervous anticipation. This moment of suspended time, with toes lifted and eyes wide, is often followed by many foot actions and a drop of the pelvis as the legs bend, knees wide open, torso stretched alertly above the grounded stance. Without pantomiming the action of a warrior fighting, the dancer embodies the emotional sensation of the battle. As in many Balinese and Javanese performance arts, the action abstracts cultural beliefs about human behavior and emotions.

The Legong is perhaps one of the most well-known Bali-Balihan dances in the West. As early as 1931, a world tour revealed the charm and amazing skill of this trio of three preadolescent girls, together with the brilliant sound of its accompanying kebyar gamelan.

Originally modeled on the duet performance of Sang Hyang, a secular version was produced in the palaces of Bali's local monarchies. After the Dutch defeated the ruling clans in 1906 and the last remaining royal family turned their krisses (daggers) on themselves and committed suicide, this valued tradition was preserved by village sponsorship, particularly in the Ubud region.

The costumes are richly ornate, with gold headdresses and gilded fabric in the long-sleeved blouses and tightly wrapped sarongs. For each performance, fresh frangipani flower stalks are tucked into each side of the headdress.

Legong is technically demanding. Complex as well as long sequences must be physically transferred to the kinesthetic memory of the trio of

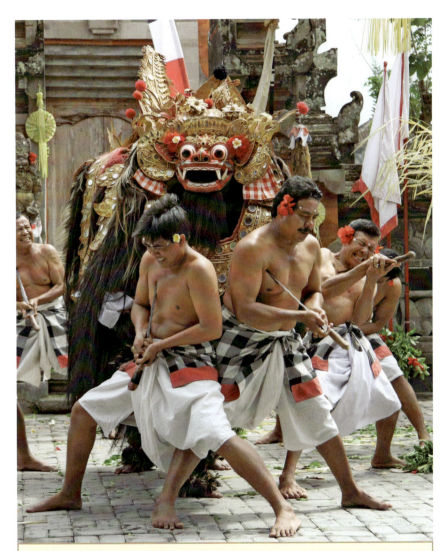

The Barong dance is a Balinese dance drama that features Barong, the spirit who protects Bali's land and forests. A lionlike creature, the Barong is typically performed by two men who have strong devotion and the ability to manipulate the large mask and body of the beast.

performers. The performance can be as long as an hour, or as abbreviated as 15 minutes. The dance, regardless of its subject, has several parts, beginning with a solo by the *chondong*, the "servant" who performs an introductory solo of birdlike movements, eyes darting up and down to right and left, in time with the gamelan *gangsas* (xylophones). After this lengthy dem-

onstration, she takes out two closed fans and performs a section of their manipulation, accompanied by the characteristic "marching" footwork, in which hips and heads swing side to side in parallel paths. Occasionally, she rises on the ball of the foot and quickly tiptoes from side to side.

Two more performers then appear, dressed identically, with matching facial features and physical characteristics. The girls themselves are as matched a set as are their costumes. The chondong hands them the fans and then departs. The duo performs a dance that consists of marching steps; postural changes that shift head, ribs, and pelvis separately or in opposition; and tiny bouncing movements that accompany their rotation of the closed fans and subsequent quivering of the fans when they open them in front of their chests as they march in file in figure-eight paths. The choreography includes crisp oppositional actions, rhythmic accents of torso shifts, and a section of drama that describes an encounter between the captured princess and an evil king. A final episode has the chondong returning as the Bird of Ill Omen, wearing gilded wings and attacking the king. Although there were other stories performed in its development, this format is the one most frequently seen by visitors in the twenty-first century.

The charm of this performance is the skill and matched physique as well as similar facial characteristics of the three petite performers. Their amazing musicality and memory for the intricate rhythmic patterns, and the multifaceted use of body parts is the result of hours of practice with their teacher as she physically imparts her experience of the movement to her students as described in the following section about instructing and learning Balinese dance and music.

A whole new genre of large, pageantlike performances combining drama, dance, and music—the *Sendratari*—was developed in the early 1960s by the artists of Bali's high school for the performing arts (SMKI). These pageantlike presentations, created in response to a Javanese *Ramayana* ballet, were enthusiastically received by the Balinese and, by 1978, the Balinese had adapted seven classics from their traditions for this new dramatic mode.

Contemporary development has continued in response to the influence of the Bali Arts Festival, an annual event in Denpasar, incorporating the benefits and disadvantages of modern amplification and huge amphitheaters, which force the expressive actions to be highly

exaggerated or discarded, due to their minimal impact on a majority of the large audiences.

MUSIC AND DANCE: TEACHING AND LEARNING

Like the Balinese calendars, musical structures are arranged in interlocking cycles, not always in synchronous phasing. It is this formal setup, as well as the metallic overtones, that creates a tension among the simple melodies and gives a shimmering quality to the gamelan ensemble. These orchestras, which accompany dance and drama, are ensembles of primarily bronze instruments, with xylophone keyboards, racks of nipple gongs, and large hanging gongs. In gamelans forged prior to the twentieth century, the pitches of the instruments were deep and the music was played with wooden mallets at a slow to moderate tempo, allowing the sound to resonate. This style, still played on ceremonial occasions, proceeds at a tempo that provides space between the pitches. This moderation brings a mellow harmonic resonance to the compositions of the older gamelans.

Bronze metallophone keyboards and gongs, bamboo flutes, jaw harps, one-stringed fiddles (*rebab*), and two horizontal drums (*kendang*) comprise the Gong Kebyar, or contemporary gamelan orchestra. The individual patterns of the groups juxtapose and interweave when played. The Balinese refer to the explosive, unpredictable quality produced by this form of construction as *kotekan*.

The gamelan leader, who is also frequently the composer, guides the performance by playing the lead drum, shifting tempi in collaboration with the dancers. His responsibility includes teaching patterns to keyboard players by sitting opposite them, playing the keyboard upside down and backwards with complete ease. This personal spatial flexibility of learning style reflects the Balinese's keen awareness of direction—geographically, physically, and devotionally—and adaptability of action according to the task.

Teaching dance also involves a variety of spatial shifts by teacher and pupil. At times, the instruction comes from dancing with the teacher, copying the action while standing behind him or her. Other times, the instructor stands behind, physically guiding body parts, manipulating the

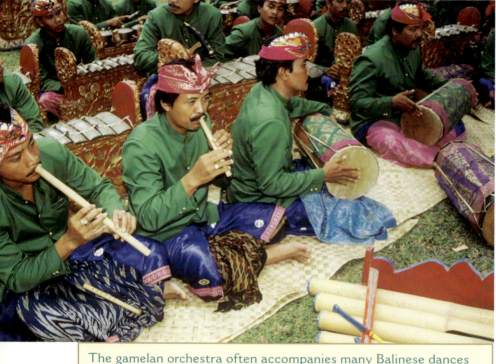

The gamelan orchestra often accompanies many Balinese dances and features instruments such as drums and gongs, flutes, metallophones, strings, and xylophones. Here, flutists and other musicians play their instruments as part of a gamelan ensemble.

head or lifting the elbows, and pushing a foot in the proper direction with his or her foot.[44] Fathers sit behind their infant children and assist them with arm movements by lifting the elbows or lightly lifting their chests up and down as they watch and imitate dancers in performance. While instructing, the teacher also mimics the sounds and rhythms of the particular dance score rather than counting, as is common in Western dance instruction. It is a very physical process between teacher and pupil.

An elderly female, who was herself a famous performer in the trio of dancers in the well-known Legong, was filmed during lessons with the chondong—the performer who starts the dance—manipulating her from behind like a tiny puppet.[45] In the film, she sharply tilts the student's head from side to side. She then places her arms under the child's, moving the pupil's elbows and wrists with her own, and grasping the tiny dancer's upper arms while pressing her body weight down until the

student's legs are flexed at acute angles. Such methods are called "putting the legong into the dancers."

The title given to the style, *kebyar*, describes the brilliant, high-pitched shimmer produced by crisply striking the bronze keys with a metal hammer, rather than the previous wooden mallets, making a bright sound that the Balinese vocally translate as *byar*, the word for lightning. Kebyar also means "to flash," or "a sudden outburst of flames." At times, the tempo shifts of gamelan music occur with startling acceleration. Colin McPhee, an American composer living in Bali during the 1930s who later wrote an inclusive text about Balinese gamelan for Western audiences, heard a Balinese compare kebyar to "the bursting open of a flower."[46]

In 1915, this newly pitched gamelan orchestra and playing style was introduced from the northern region of Bali near Singaraja. From the village of Jagaraga, Gede Manik became well known for his teaching. Traveling south, he brought the new craze to villages eager to learn it. They then immediately began to infuse it with local and classical styles. In this way, each village made its kebyar unique. Various popular styles began to intertwine and created great enthusiasm throughout Bali for the new music.

NEW DANCE: MOVEMENT STYLE AND VOCABULARY

Prominent in the development of dance repertory to be performed with the new music of the twentieth century was I Nyoman Mario, a young dancer who first heard Kebyar in 1919, when the King of Tabanan, a southern province in Bali, sent for a northern group to play for an important cremation ceremony.

In 1925, he created the first dance for this new musical style, calling it *kebyar duduk*. In Balinese, *duduk* means "sitting," and the physical demands of the 20-minute dance include traveling and bouncing in a squatting position for an extended time in the middle part of the performance, which is very hard on the legs.

In the structure of this dance, the performer enters a space where the gamelan is arranged in a semicircle behind the dancer, with a rack of *trompong* (big nipple gongs) at the front, between dancer and audience.

The dancer wears a tightly wrapped length of bright cloth around his torso and a long batik train attached to his wrapped sarong. The tone of his performance is flirtatious and sensuous, eyes flashing back and forth, accompanied by an enigmatic smile. He wears makeup, with heavy emphasis on the eyes, and bright red lipstick.

The upper body is quite active in this dynamic, changeable, highly embellished style. The chest juts sharply from side to side. The elbows— bent at a right angle with the wrists flexed back—rotate quickly from the shoulder and the dancer crisply flips his hands up and down.

Darting eyes and a lightly bouncing reverberation of the body above the knees accompany this tremulous action. The speed, along with unexpected shifts of tempo, body parts, and direction, holds the viewer's attention on the changing nature of the movement and dynamics. I Made Bandem, Rector of the Indonesian Institute of the Arts (ISI) describes it as a "character study of a young man."[47] It combines bravado, anticipation, surprise, delight, and sensuality in quick succession.

After this opening foray into the personality of the youthful dandy, he moves to the trompong, picks up the mallets, and crouches down to a cross-legged, seated position to play it. Skittish and playful, he twirls and brandishes the mallets like batons, in between striking the knobs of the big gong pots resting in their wooden frame.

At intervals, he puts the mallets down and takes hold of the long batik train attached to his wrapped sarong, flourishing and displaying the fabric as he bounces in little circles at ground level, like a tiny bird. Flirtatiously darting his eyes and shifting his chin from side to side, he resembles a prairie chicken in his bobbing and weaving courtship rituals. Rising, he performs a final brief section of torso manipulation, facial flirtation, and arm gestures as he retreats from the dancing space.

The invention of the kebyar style, its secular nature and choreographic format, started a wave of enthusiasm that has prevailed since 1925, and the endurance is now similar to that of classical ballet in the west. In 1952, shortly after Indonesia gained its independence from the Netherlands, Mario was asked to create a new kebyar-style dance by the directors of a tour that was set to visit Europe and the United States. They recognized the need for material suitable for these audiences, who were unfamiliar with the language or the cultural milieu. In response, he created a male-female duet, *Oleg Tumulilingan* ("Bumblebees"), in which an abstract depiction of bumblebee courtship was set in a flower garden. Flirtatious and

ENERGY USE IN BALINESE PERFORMANCE

In *The Secret Art of the Performer*,[48] Eugenio Barba and Nicola Savarese wrote about human performance behaviors they encountered in their transcultural research, seeking the affinities and differences among cultural groups in behavior intended for such purposes.

Balinese describe performance energy as manipulated between two poles: *keras*, which is strong or hard and the result of vigor, and *manis*, its counterpart, which is soft, delicate, or tender and may appear weightless. These energy uses are likened to *bayu*—wind or breath—and can be present simultaneously in different body parts, animating the dancer's energies in these contrasting fashions.

The Balinese identify three movement styles that produce specific characterization by manipulating bayu. Halus is refined, polished, smooth, and "perfect"—indicative of a character of heroic proportions or a person of royalty. Alus is refined, smooth, and seldom moves in a jerky fashion, traits related to halus behavior. The counterpart to these characteristics is the kras persona, who is rough, demonic, big, unrefined, and given to harsh movement. Kras behavior is usually danced by a topeng (masked) or painted-face character.

decorative in its movement, it was well received on tour and captivated the Balinese audience when the company returned to Bali.

Provocative and playful, the cultural impact of Mario's kebyar repertoire on the Balinese can be compared to that of choreographer Bob Fosse's style of sensual jazz dancing on Americans, from the early 1950s to the recent revival of *Chicago* on stage and in film.

Kebyar Duduk is clearly a Bali-Balihan creation, yet it too can be requested for performance in the outer courtyard at an Odalan. Its popularity and beauty make it an attractive offering to the dewa.

5

China: Vast and Ancient, with a Love of Music and Dance

China's long dance history is recorded in pottery, painting, poetry, and performance. No region is without its identifying folk dance, and performing troupes in each region come together for celebrations such as Britain's return of Hong Kong to Chinese sovereignty in 1997. New works for classical forms such as Chinese Opera are still being created, as well as for imported styles, such as classical ballet in the Russian style and, more recently, modern dance from the United States and Canada.

During the Shang dynasty (sixteenth to eleventh century B.C.), dances of *shamans*, those who performed sacrifices and divination, were used to communicate between the gods and humans. This ability gave them high status and power. Later they danced to drive out evil spirits and epidemics. Consequently, they held high esteem in their communities.

As early as the eleventh century B.C., in the Western Zhou state, ritual music and dance were significant in "paying homage to Heaven, Earth and Ancestors, and at court celebrations."[49] Dancing was used in ancestor worship and in representations of battle. Making history visible

this way, with group formations symbolizing union, emphasized the complex relations necessary for good government, as well as the significance of martial arts to maintain such balances.

Dances of colorful beauty honored earth and grain gods. Bronze utensils from the period, used for storing cowry shells, were decorated with dancers marching around the circumference, wearing tall feather headdresses and carrying long staffs with parallel feathers forming a banner on each upright staff.[50] Copper plates also portray a variety of scenes, including dancers with varied costume parts and implements such as shields, yak tails, colored plumes, and lengths of silk cloth or fur.

The Zhou court supported national minority dances as well as those by members of the ruling monarchy, which were performed at banquets. Sixty-four dancers made up the royal dance troupe, performing in descending sizes of square formations; the first was made up of eight rows of eight dancers. They were followed by 36 feudal lords, who formed six rows of six. Finally, 16 high-ranking officials performed in four rows of four.

By the fifth century B.C., in the Warring States period, martial arts training and clan dances for keeping fit were well established. Manipulation of long sleeves was established and became a popular focus for dance gesture, now seen as a hallmark of later developing Chinese Opera performance. A Neolithic earthenware bowl, with dance figures holding hands and progressing clockwise around the inner side of the rim, was unearthed in Qinghai, according to author Kefen Wang, who likens it to a Han recreational group dance that celebrates the animals in such a dance, masked and costumed in fur.[51]

This ancient example suggests the significance that dancing has held for not only the Chinese but also the cultural groups of the entire northern and middle Asian continent. A number of other illustrations in Wang's book *The History of Chinese Dance* display the emphasis on the sleeve movement in T'ang and Han murals, figurines, and carvings, which has been retained up to contemporary performance of the Chinese Opera as well as in local styles.[52]

Aside from the use of sleeves, the use of paraphernalia is also a common trait in Chinese dances. A scarf dance is repeatedly pictured in Wang's book, in reliefs, carvings, and cave paintings from Han (207 B.C.– A.D. 220) and T'ang eras (A.D. 618–907).

Paraphernalia, such as silk scarves, is an important component to many dances in China. Here, a Chinese dancer performs a traditional folk dance using silk scarves.

The Zhou ritual system of court dance and music was sent into turmoil after a slave revolt and assassination of the dynasty's leaders during the Spring and Autumn and Warring States periods, which ended in 256 B.C. [53]

In the early dynasties, the dances in China were associated with the emperor's power and his desire to have the support of the gods.[54] When Buddhism arrived, the Chinese, Tibetans, Bhutanese, Nepalese, and other cultures created dances associated with the ritual life built around the worship of Buddha as a god, rather than Buddha as a teacher, to be revered and followed for his philosophical perspectives.

Tibetan Buddhism's dances abound with demonic beings and are frequently masked performances. They bear some resemblance to Native American dances of the American Southwest. The exception in China was the Buddhist sect whose focus was release (*satori*) and who developed the Zen sect of Buddhism (originally called Ch'an Buddhism by the Chinese), which has flourished in Japan.

CHINA'S ENDURING RELIGIONS: TAO AND CONFUCIANISM

Lao Tzu was born in about 604 B.C. and, according to philosopher Huston Smith, Confucius, who was Lao Tzu's junior by about half a century, "likened him to a dragon—enigmatic, larger than life, and mysterious."[55] Smith notes that according to legend, as Lao Tzu was departing China for Tibet on a water buffalo in search of greater personal solitude, the gatekeeper tried to persuade him to stay. Having no success, he asked Lao Tzu to write of his beliefs for the future of China's citizens. Lao produced the *Tao Te Ching* (pronounced "Dao Deh Ching") in only three days. Its title translates to *The Way and Its Power*, and, in spite of the brevity of its content, it is still the basic text of Taoism. Scholars speculate that it was compiled in the latter half of 3 B.C. by an individual who brought together its various ideas in a coherent manner.

Tao means "Path," or "the Way." As Smith describes it, Taoism considers reality, in all its vastness, as the source and final destination of all life-forms as well as the daily existence of what we define as reality, or

the world. Its second characteristic is the driving power in all nature.[56] Spirit is important, not matter; and the Tao is inexhaustible and inevitable, as is death or decay. The relationship between human life and the universe is the source of the Tao's commentary and recommendations.

As practiced, Taoism has taken three forms. Religious Taoism has emphasized belief, which "made cosmic life-power available for ordinary villagers."[57] Ritual, texts, and magic are essentials in its practices, much as they are in Christian traditions (gesturing the sign of the cross and the breaking of bread; biblical knowledge; and miracles such as the loaves and fish).

The second form, vitalizing Taoism, focuses on the creation of energy and its unrestrained flow—*ch'i* (literally "breath" but referring to vital energy: the flow of physical and mental powers coursing through the body). Maximizing ch'i is the identifying goal of these Taoists, who practice training programs of various kinds, all meant to reduce obstacles to the free flow of ch'i.[58] In one of these vitalizing approaches, Taoists focused on hygiene and diet to maximize ch'i, or vital energy, practicing meditation to empty the mind and allow more room for ch'i to enter, as well as performing exercises to allow ch'i to be absorbed through the breath. They tried eating things to see if ch'i could be digested. Their aim was achieving *wu wei*—"pure effectiveness"—by reducing friction between individuals, opposing groups, and between humans and nature.

Engaging the mind to increase or preserve ch'i through meditation is the technique engaged by the third type, philosophical Taoism. Direct exposure to the source of awareness led to the understanding of the origins and vehicles of perception, not just things perceived. Transferring the power attained by experiencing these metaphysical states to the larger world was the goal of this third, more allusive, ch'i-centered practice of the Taoist yogis, who engaged in meditation as a means to accomplish this state.

The Taoist symbol of the circle, with two fishlike shapes in positive and negative colors nestled inside, represents the flow of two opposites of *yin* (the dark, wet "female") and *yang* (the bright, reflective "male") in both opposition and cooperation of flow. The Taoist goal focuses on the flow—maintaining the balance and cooperation of these in the support of life at its most realized level.

Confucius, a native of what is now Shantung Province, west and south of the Korean Peninsula, lived from about 551 B.C. to 479 B.C. He is known best as a teacher, whose basic philosophy was similar to the Golden Rule: "Treat others as you would have them treat you." Confucian thought, emphasizing knowledge, the classical, and formal relationships in life, provides a type of yang in balance and opposition with Taoism, which holds a more romantic, yin perspective, with a nature-centered outlook.

Human welfare is the greatest emphasis in Confucianism, which focuses on the relationships between "superiors and inferiors," an opposition that is based on age—the old are wiser by virtue of experience and those younger are to revere and learn from the superior's knowledge. This philosophy translated into extolling the relationships and responsibilities of the family and superimposing them on the "family of society." It became an ethical code of human interactions, based on the expectation of the essential goodness and ethical behavior of all. Confucianism has also placed a strong emphasis on formal education, as well as responsibility for "correct relationships" to be maintained between individuals, according to their stature, age, and role in society.[59] In particular, this included ancestors, who were to be increasingly worshipped and revered the longer they had been dead.

DANCE IN ANCIENT CHINA

Kefen Wang introduces *The History of Chinese Dance* with an ancient Chinese definition of her subject: "Dance is the art of portraying a certain state of mind through the ordered rhythmic actions and configurations of the human body."[60] Early Chinese dances were created in response to the need for physical fitness, as well as in celebration of battle victories. As early as the eleventh century B.C., the Western Zhou dynasty worked out an elaborate and far-reaching system of ritual music and dance as tributes to past military victories in sacrifice for future support. Devotional dances honoring clan animals and praising gods were recorded in the Warring States period (770–476 B.C.).[61]

The Book of Rites, a Confucian classic that describes ceremonial activity in ancient China, places the instigation for dancing in the sound

that "issues from Man's innermost being," and declares that "Man's feelings are excited by the external world." All this produces "music," which is the combination of song, poetry, and dance as well as instruments, which "were considered as arts for expressing Man's ideas and feelings."[62]

However, dance could also be used for ill purposes. At an important political event in 500 B.C., Confucius denounced the dancing at the event as corrupting the feudal lords, who were immediately killed as a result. In contrast, he was moved by the "shao," a dance that had been created in primitive times to celebrate the success of a huge project for flood control.

Chinese ideas about the essence of nature and the proper relationships between individuals to benefit both society and themselves were the basis of the plots and emphases in what later came to be the Chinese Opera, the most familiar of China's performing arts to the world outside of China.

Wang notes that, in primitive society, dances reflected martial life with spears, shields, and other weapons for communicating threats, while feathers expressed a message of peace and friendship.[63] Religion was reflected in clan dancing praising heroes, and in homage to Heaven, Earth, and the Ancestors. The "doctors" of the day were trance mediums.

Philosopher Mircea Eliade notes that, "From the earliest times, the classic method of achieving trance was dancing." Bon mediums, who used drums in their rites, also became a "temporary mouthpiece of the dead, who had later to be conducted to the other world," with the use of drums as vehicles to travel through the air.[64]

Lion dances, possibly one of the most likely Chinese dance forms familiar to those outside China, were popular prior to the T'ang dynasty, even though lions have never been native to China (instead, they were brought in as gifts to the Han Court). Their movements were imitated as early as the Three Kingdoms period (A.D. 220–280) and passed into Chinese culture down to present-day variations that can be viewed on Web sites.

CHINESE BUDDHISM

Life's goal, according to the Buddha, is "to extinguish," as in a flame dying out. The word Buddha used for this was *nirvana*. This state is one

One of the most renowned Chinese dances, both in China and throughout the world, is the Lion Dance. From the time of the Three Kingdoms period (A.D. 220–280), the movements of lions have been imitated in Chinese dance.

where private desire has been consumed and all restrictions have been exhausted. Another way he addressed the question was by replying that nirvana is "bliss." He viewed the soul as a wave. It swells up; it comes, rising and descending; and then it passes and is gone. It is made up of a changing content as it flows past and can have different natures, but its constant "form" is water or possibly "waterness."

In fact, two of the prominent analogies of Buddhist imagery are voiced in the Big Raft and the Little Raft, Mahayana and Hinayana Buddhism. The *yana* image is of two rafts that carry people across life's river. In the first branch of Buddhism, Mahayana, "release" is a fact. Buddhas and Bodhisattvas work for us and provide "grace" for our afterlife.

In the second branch of Buddhism, Hinayana, wisdom sees us through, with insight into reality. But this doesn't come without work on our part; compassion must be cultivated to bring understanding. The *Sangha* (Buddhist monastic order) is the core of Hinayana. We,

having been blessed by Buddha's existence, bear the responsibility of our grace and can also renounce it in order to help others achieve it. China's interest in Buddhism was of the Mahayana style, which was influenced by Taoism. It relied heavily on personal meditation. This Buddhist path was carried by the *Bodhidharma*, who brought Zen to China.

The struggle for control of China during the twentieth century brought Communism to the fore. Communists waged war on religion first because it was too tied up in old political views of human relationships. A number of Taoist and Buddhist temple grounds were closed by the Communists, but many have now been reopened, with the idea that revolutionary visions have changed people's relationship to the politics of these religions.

T'ANG DYNASTY INNOVATION: CHINESE OPERA

In the T'ang dynasty, the swirling of long scarves and lengths of silk fabric created a stunning impression, and sleeve dances have long fascinated the performers and audiences of China as well as audiences around the world. The expressive choreographic action of extended sleeves has long been a part of the vocabulary of China's dance, beginning in the Han period. The stories that were displayed through the dance originated in Confucian society, with understood relationships among family members based on respect and duty.

Emperor T'ang Ming Hwang was a creative leader and patron of the arts. Under his reign, there was a synthesis of excellence in many fields—literature, calligraphy, poetry, and administration. A year after his enthronement in A.D. 713, he established the Music Workshop in the capital of Chang-an. The students practiced in a palace near the Imperial Park, not far from the Pear Garden. Adopting the name, they were thereafter known as Students of the Pear Garden. Dynasties later, T'ang Ming Hwang was declared the patron god of the theater, with preperformance prayers offered to him before each event.[65] The Pear Garden identity has remained attached to the acting profession; Chinese Opera has been known since 1949 as the Red Pear Garden,

which identifies its politics and important relationship as a vehicle for education with the present Communist rulers of the People's Republic of China.

In addition to the formal theater developed in the T'ang period, the dances of national minorities were incorporated into court presentations. Military experiences were also imported into T'ang dances, such as the dance "Music of Breaking through the Ranks," which celebrated the ascension of Emperor Li Shimin in A.D. 633. The dance troupe's size—120 strong—exceeded previous numbers and added greatly to the political significance of the event. The dance, in three parts, had complex forms based on nature and military actions praising Li Shimin's victory.

It should be evident from the above that, as author Gloria B. Strauss points out, "Dance and ideology have been closely related in China since the earliest times, and it is because of this that a change in the latter has resulted in a change in the former."[66] In fact, Strauss comments, "This notion that ideology *should* command culture is very ancient in China."[67] *The Book of Rites*, compiled near the end of the first millennium B.C., became one of the Confucian classics, intended for study and application by officials. It contains "minute details of ritual and social observance," including a prescription for peaceful government that requires music that is "peaceful and joyous," rather than resentful and angry (countries in confusion) or pensive (with its people in distress).[68]

CONTRASTS IN WESTERN AND EASTERN PERFORMING ARTS

Very little traditional Asian drama is solely script-oriented, as is most traditional Western drama. With the exception of occasional experiments, Western movement is intended to convey the illusion of realism, emotionally and descriptively supportive of the development of character and plot. Realism dominates over spectacle (with the exception of some styles of musical theater developed in the twentieth century). In the West, dance has primarily been a physical art and drama a verbal one, while opera has focused on the musical aspects.

Moreover, Western opera is primarily the domain of singing, whereas Western acting is conversation supported by action, and dancing is movement performed to be experienced for its own sake, and may or may not convey realism in its expressive message.

In traditional Asia—as well as in much of its contemporary development—the elements of singing, acting, and dancing have been combined for the total impact of sound, action, verbal communication, and their many dynamic combinations. In China, the major form of this type is identified as the classical Beijing Opera, or merely Chinese Opera, to indicate the form, not its specific genre. In each case, these forms with their variations are firmly rooted in local culture and worldview.

After the People's Republic of China was created in 1949, pressure was put on traditional society from the Communist Party "to regard theater as a weapon of the Revolution and to incorporate Western stage techniques." Due to the leadership of Jiang Qing (Mao Tse-tung's fourth wife) in the context of Communist China's "Great Leap Forward" in 1958, opera was slated to become "a primary weapon of propaganda."[69] In spite of this attempt, by 1959, only one out of seventeen plays performed was a modern opera.

CHINESE OPERA IN THE TWENTIETH AND TWENTY-FIRST CENTURIES

The attempt to revolutionize the Chinese Opera and create a new repertory entirely based on revolutionary themes has not been entirely successful. Popular historical plays have returned to the repertory, partly due to the appreciation of the Chinese for their performance elements and musical values. Chinese Opera continues to draw new students who wish to be involved in political theater, but the classic plays still attract audiences not only for their music but also for the actors' characterization and visual display. Heavy makeup identifies both the characters and their emotional identities. Rather than realism, the opera uses symbolism of color, design, body posture, and walking style to communicate instantly to the knowledgeable playgoer.

One example is the specific makeup for a young woman, which begins with a white base and blends in red for contour and identification of her character. All characters display highly exaggerated eyebrows and heavily colored lips, and wear wigs appropriate to age and station.

A specific group of characters, "Painted Faces," reveal their nature by the colors and patterns that are used to indicate their particular temperaments. They are frequently rogues, malicious and untrustworthy. Sometimes the facial features are almost negated by the patterns, so the humanness of the actor/character is obliterated and he comes to symbolize fear by his anonymity.

Head movement plays a prominent part in both male and female acting. A particularly notable variation involves a releasing of tension at the top of the neck, allowing the head to tilt and slide in small figure eights, snapping into a sharply held focus at the climax of a particular phrase. Walking styles, studied at length, identify age, vocation, class, and personality types.

Singing is highly stylized and also identifies the gender and station of the character. A hallmark of the genre is the climaxing action of the phrase "winding up"—a flurry of action of many body parts and arresting motion in a sudden accented freeze to tense stillness, while eyes are open wide. This is accompanied by musical accents of high pitch and reverberating gongs that shimmer as the frozen actor draws out the drama of the moment.

Training begins early in youth and starts with the development of flexibility, range of motion, strength, and buoyancy that are required for combat skills and acrobatics, ranging from the elementary somersault to handless cartwheels and double front flips used in battle scenes. Instructors provide hands-on physical support as their students attempt these skills, guiding and assisting them in developing the risky moves as second nature.[70] The stage has very few items of scenery—a table, chair, and possibly a doorway—which suggests an environment that is brought into dramatic focus by pantomime, song, action, and musical movement.

Battle training with weapons is another physical skill to be perfected, as are the many tones that are employed vocally for expressiveness. *Wuzu* are those who specialize in martial arts and work with swords and sticks, twirling, tossing, and juggling them in flamboyant displays of skill that threaten real danger at every move. Both male and female

warriors participate in combat. A general is recognized by flagsticks that are attached to his shoulder girdle—the number of which indicates his army's size. The colors worn represent opposing sides in battles: blue identifies an emperor's troupes, while yellow signifies peasants.

It is not uncommon to see a sizable number of warriors on the silk-carpeted stage, tumbling, jumping, and side-somersaulting in a display of battle that ends with the combatants suddenly freezing into stillness in an expressive pose of aggression, while gongs crash and echo repeatedly. Such sounds are not only musically employed but also create sound effects as well. The orchestra includes bowed and plucked string instruments, flutes, wood clappers, gongs, and drums.

Recently, modern touches have sparked the dramatic and technical elements in some troupes' performances. One example can be seen in the *JVC Video Anthology of World Music and Dance*,[71] an astonishing, recurring quick change of a mask's facial expressions and colors (at least six varieties), which, although they are traditional elements, seem to occur with the cooperation of electronics and change the shape and form of the many expressions in a flash.[72]

DANCES OF THE MINORITIES

In the Yuan (A.D. 1279–1368), Ming (A.D. 1368–1644), and Qing (A.D. 1644–1911) dynasties, the tension between classes and nationalities created an atmosphere that oppressed the development of dancing. Kefen Wang describes a search for an artistic form that would express the feelings and reality of the harsh lives led by the people under the oppression of the ruling class.[73] They turned to traditional opera as a vehicle of this desire. Rather than song and dance, they brought together "literature, drama, music, dance, fine art, martial arts, and acrobatics, which developed into what has become traditional opera, with dance taking a large role in its expressive content."[74] However, dance continued to be active in regional festivals, eventually resulting in the creation of troupes of local minorities. In the current era, these troupes have developed their dances into popular stage performances, with enthusiastic followings in their regions as well as for national performances. The Han National Minority has a large, theatrically oriented repertoire.

HAN FOLK DANCE

Dance is an important part of Chinese culture, and with 55 different national minority groups, it varies quite a bit. The largest of these ethnic groups is the Han, which make up approximately 90 percent of China's population. The Han have a strong folk dance tradition, highlighted by the dragon dance.

For the Han, dance is based on the acts of mythic culture heroes. Many of these dances are related to the harvest and hunting and the relationship the gods have in helping to ensure that these endeavors are a success. For example, the Constellation Dance was traditionally performed to procure as much seed grain as there are stars in the sky, while the Great Ode to Emperor Yao (approximately the twenty-second century B.C.) was performed in preparation for what the people hoped would be a prosperous hunt. Some other examples of these dances that were closely tied to the struggle to survive were the Harpoon Dance, connected to the deity Fu Xi, who gave the Han fish nets; the Plough Dance, associated with Shen Nong, the deity of Chinese agriculture; and the Dance of the Cloud Gate, given to the Han by the father of their people, the Yellow Emperor.

In addition to dances that promoted everyday survival, many traditional Han folk dances were based on totemic worship, the belief in the mystical relationship of humans and an animal or natural object. For the Han, one of the most important totems was the dragon, which could be traced to the deities Fu Xi and his sister, Nu Qa, who were semi-human and had snake bodies. Over time, other ethnic groups' beliefs and totemic figures were combined with those of the Han, including animal legs, deer hooves, dog

(continues)

(continued)

claws, and fish scales, among others, to create the dragon of today. Though the dragon is no longer worshipped, it is an important part of Chinese society. For example, the emperor was long known as the Son of the Dragon. In addition, there are more than 700 different dragon dances performed in China. The dance is presented the most at the Spring Festival, the traditional Chinese New Year, and during the Lantern Festival.

Another celebrated dance in which the dragon takes center stage is the *yangge*, or rice planting dance, which is common in northern China. This dance is bolstered by drums and singing and includes both fast and slow rhythms and an arrangement of backward and forward steps. In rural areas, the dance may be a measure of a larger performance that includes drama and singing. A similar dance to the yangge is the lantern, or flower lantern, dance, which is found in southern China. Though all of the dances have their own characteristics, they share many similarities, including arc movements using the arms and hands and undulating body motion with accentuated lower-back movements and upward elongation of the back. In addition, these dances also feature dexterous circular arm and hand movements. The performances of both the yangee and Lantern Dance impersonate reptilian, or dragonlike, movement. And these gestures are further tied to the dragon through their names: dragon's tail thrust, two dragons blowing their whiskers, and golden dragon curling around a jade pillar.

Wang describes a national celebration in 1964, "the fifteenth anniversary of the founding of New China."[75] Premier Zhou Enlai was in charge of organizing more than 3,000 professional and amateur artists in the writing and staging of a large format music and dance epic called the "East Is Red." It included events in the Chinese Revolution by

"incorporating works of music and dance representative of each histori-cal period"[76] as well as inspiring postliberation creations that evoked strong feelings from the audience. Following this triumph, the Cultural Revolution in 1966 oppressed and obliterated literary and artistic pro-duction, declaring all festivals "feudal and backward," and abolishing such activity. October 1976 saw the fall of the Gang of Four—Com-munist Party leaders Jiang Qing, Zhang Chunqiao, Yao Wenyuan, and Wang Hongwen—which led to the liberation of the arts once again, and, in 1980, Beijing hosted two festivals and held a competition for solo, duo, and trio dances, initiating another surge of enthusiasm for national dance performance.

DANCES OF TIBET

Within the geographical domain of China, Tibetans were an advanced society that instructed the royal family of Manchu emperors in the Ti-betan language so they could read the prayers in the Buddhist scriptures. Tibet's government considered itself to be responsible for the well-being of humanity in the world, and, in 1946, addressed Chinese president Chiang Kaishek with a letter conveying its religious national pride.[77]

Tenzin Gyatso, the fourteenth Dalai Lama, or spiritual leader of Ti-bet, was forced to depart his homeland in 1959, fleeing from the attack of the army of the People's Republic of China. Although the Dalai Lama's story is well known, it may be a surprise to some that his branch of Bud-dhism is one in which dancing is an integral part of ceremony. The film *Echoes from Tibet*[78]—made in 1980 in Leh-Ladakh and Dharamsala, In-dia, during a visit from the Dalai Lama—pictures a number of dance dramas, including a pantomime of yaks (Asian buffalo) performing phrases of step-hops interspersed with rolling on the ground. This is ac-companied by flat, handheld drums about 18-inches wide, played with a curved stick, and cymbals. As in many Tibetan dances, there is comic byplay in the choreography; in this instance it details the temperamental nature of yaks and includes a pantomime of milking them.

The goal of dance and the other arts in Tibet is to promote the death of evil. Most Tibetan Buddhist dances take place in a limited outdoor space, with the audience surrounding the performers. In a dance by the

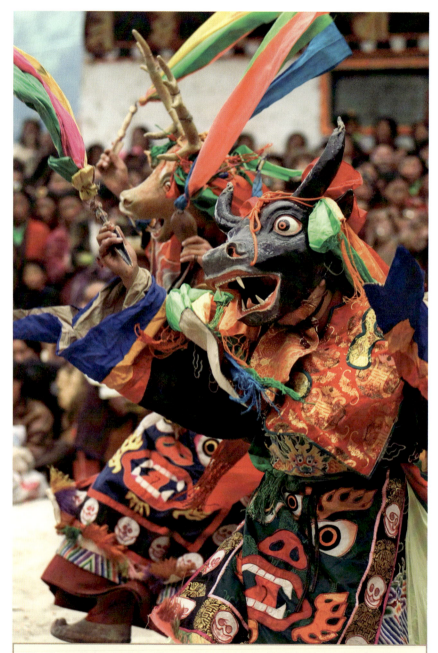

The Lion Dance and other animal dances, such as the Yak Dance, demonstrate that animal representation has traditionally played an important role in Chinese dance. Here, Yak dancers perform at the Monlam Chenpo Katok Dorjeden Monastery in the Kham region of Tibet.

Black Hat sect called "Dance of the Sorcerers," children perform briefly, manipulating long sleeves, and then a quartet of men, walking and hopping in unison, make figure-eight patterns with their long sleeves and blue scarves held in their hands. Long skirts and long slender tunics are worn over red blouses, and they wear flat masks modeled to the shape of their faces. Changing places in the circle and moving in unison and opposition, they perform a dramatic battle of good and evil that lasts seven hours. Most prominent visually are the drums, cymbals, and slender horns stretching in a curve about three yards long and resting on the ground. The dancers hop and twirl at a moderate pace in their gold masks as prayer wheels are turned nearby.

In another quartet performance, men wear peaked hats approximately two-and-a-half-feet tall, with carved leather designs in flat wings above the conic peak. They have long-sleeve inserts and hold scarf strips in their hands. This time, the telescopic long horns are accompanied with brass cymbals. Long strips of fabric that hang from the hats are held close to the body with crossed lengths of cloth, which keep them from tangling as the dancers hop and turn. Big skirtlike garments of brown, under colorful overlays of bright stripes, have an apronlike front panel, from which a demonic face with big, open eyes looks out. The dancers perform step-hops with bent knees, then add another hop to the phrase, gesturing their scarves up and down.

Buddhism was long in coming to Tibet (A.D. fifth century, 900 years after Buddha's life and teaching), but by the mid-eighth century, Buddhism had spread far and wide, struggling against negative forces and mountain spirits who were hostile to Buddha's *dharma* (teachings). The powerful Guru Rinpoche ("Precious Master") traveled from Pakistan to India, and then to Tibet, where he built a monastery and taught scholars Buddha's teaching, which they translated for Tibetans' education. Known also as *Padmasambhava*, the "Lotus-Born," Rinpoche manifested in visions as deities who "danced in a thousand majestic ways." These dances brought visions to specific monks, who then taught them to their fellow monks, inaugurating festivals for the performance of the dances.

A spectacular aspect of these dances is their huge masks, painted bright gold, blue, red, and white, and set off by brightly decorated, multicolored silk brocade costumes.[79] Animal representation is common. A dance described and pictured in *Monk Dancers of Tibet*[80] features two bird

dancers—one in an owl mask, the other a crow—who are later joined by four guardians with mask heads of a vulture, lion, crane, and wolf. These are symbolic of "four limitless thoughts": lover, compassion, joy at others' happiness, and impartiality. Each wears a brightly colored sweeping robe with a contrasting lining and large, sweeping sleeves. The dancing is simple: step-hops with high-lifted knees and turns that display the power of presence due to the elaborate and brightly colored costumes.

Another dance pictured in *Monk Dancers of Tibet* is a stag dance that features a large mask with projecting antlers. The dancer "annihilates the ego" through the dance and reminds Tibetan viewers of a complex story of assassination as well as a legend of pursuit and trickery.

The "golden libation" features a black hat about one-and-a-half-feet in diameter and two-and-a-half-feet tall that is adorned with figures of the sun and moon as well as a skull at the top. The costumes are made up of many layers of brightly decorated and colored cloths with designs of wrathful faces, eyes, stripes, loops, stars, and replicas of gold instruments held in the hand during ceremonies. Lines of black paint elongate the length of the dancers' noses.

The display of physical beauty or spectacle is not what makes Tibetan dances so alluring but rather their spiritual beauty, which leads to enlightenment and "a direct experience of inner peace, free from attachment to the illusory solidity of the ego and the phenomenal world."[81], Matthieu Ricard describes dances in *Monk Dancers of Tibet* as "full of symbolic meaning. For instance, when a lone dancer in a stag mask cuts up an effigy with a sword, it is not an act of violence, but symbolizes destroying the ego with the sword of wisdom."[82]

This is but one of the many profound symbols that are embedded in the dance tradition in Tibet. When, in 1959, the Chinese Communists attacked Tibet, repressing its Buddhist monasteries and causing the young Dalai Lama to flee to India, the dances were preserved in exile in Nepal, Bhutan, and India. *Cham*, a sacred dance of the Shechen monastery in eastern Tibet, was one such dance that was preserved in Nepal and was described by Ricard as "one of the most beautiful examples of Tibetan art in exile."[83] In 1985, the monks were permitted to return to Shechen and revive the monastery and traditions of dancing, and the monastery has been partially restored after it had been destroyed by the Chinese in the late 1950s.

Japanese Performing Arts

Japanese culture has been engaged with movement as ritual, ceremony, celebration, and entertainment from its earliest days as a developing civilization. The creation of the Japanese *archipelago* was envisioned in the Shinto belief system as the work of three spirits, who spontaneously materialized two additional spirits: the drifting young earth and a reed shoot that emerged soon after. The quintet separated heaven and earth, and six pairs sprang up spontaneously. The final pair—Izanagi (The Male Who Invites) and Izanami (The Female Who Invites)—were siblings, who were given a jeweled spear in order to give birth to Japan. Stirring, they dripped brine from the sword blade into a pile, which became the initial island. Then they joined in union to give birth to the remaining eight islands, along with thirty spirits of the elements, seasons, and universe. The last element, fire, caused Izanami's death in the throes of birth. In anger, Izanagi beheaded fire. From the splattered blood came many more spirits.

A series of such combative incidents ended in the appearance of three important spirit siblings: Amaterasu O-Mikami (The Heaven Shining Great August Spirit), Tsukiyomi-no-Mikoto (His Augustness Moon Night Possessor), and the storm god, Susano-O-no-Mikoto (His Brave Swift Impetuous Male Augustness).[84] Amaterasu O-Mikami hid

in a cave after her brother, the storm god Susano-O, offended her. This had the disastrous effect of depriving both the gods and the earth of the sun's life-giving light. Amaterasu was enticed to emerge after Ame-no-Uzume-no-Mikoto (goddess of the performing arts) danced a noisy, erotic dance on a wine barrel, an act that established dancing as central to Shinto worship. Subsequently, dance was emphasized in all drama in Japan. In *Noh* theatre, which portrayed Buddhist themes, the performance retained the ritualistic and supernatural indigenous elements of Japan. Uzume's dance also established the presence of the boisterous and the erotic as components of the vocabulary of Japanese dance. These appear prominently in *Kabuki* theater, as well as the late-twentieth-century *Butoh*. Uzume's mythological dance provided the model for using percussive movement and accompaniment in all forms of the dance. The dance was also the model for the presence of resonating chambers

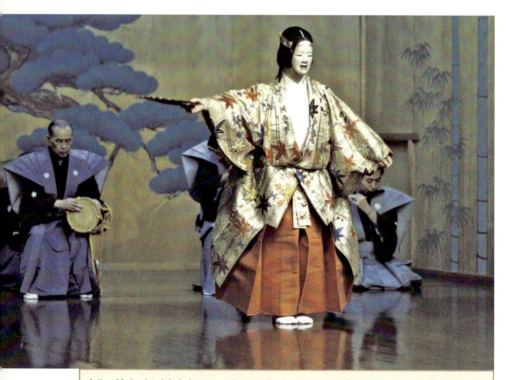

Like Kabuki, Noh has traditionally been one of Japan's most famous forms of theater, despite a decline in popularity during the Meiji period (1868–1911). Dancers from Noh troupes travel throughout the world.

(similar to drums or wine barrels) under the wooden stage floors to enhance the sound of foot beats, which are part of the characterization and movement vocabulary of Japanese traditional dance.

In his 1962 book, *The Masks of God: Oriental Mythology*, author Joseph Campbell recounts a story that reveals the Shinto predilection for dance. After witnessing a number of Shinto shrine rituals, a Western sociologist remarked to a Shinto scholar: "I don't get your ideology. I don't get your theology." The revered scholar's thoughtful response was: "We don't have ideology. We don't have theology. We dance."[85] This emphasis on body-mind experience, rather than a philosophical or argumentative view, has been a prevailing cultural preference for the Japanese.

Confucian influence began to enter Japan from China as early as the fourth century A.D., and was well established by the late sixth century. Confucian ideas affected not only moral and ethical behavior but also reinforced existing, indigenous needs: to have rites (which include dance and music) in order to assure the emperor's success in maintaining his reign.

THE INDIGENOUS DEVELOPMENT OF PERFORMING ARTS

Three traditions influenced the form and styles of performing arts the Japanese have developed. One was the importance of ritual and ceremony, which was a characteristic even in the early Yamato period (A.D. 250–710). In A.D. 297, a Chinese traveler, who was visiting "the people of Wa," as the Chinese called them, reported practices in divination: the baking of bones, together with their careful examination in order to determine if fortune would be good or bad.[86] The first identifiable imperial family was designated in the mid-sixth century. Importations from the Chinese and Korean mainland increased the elaborateness of the court's social ceremony, thereafter intertwining imported ideas of hereditary values with local situations of real power. This mix of the pragmatic and formal were also adopted as conventions in theatrical practice, particularly in the later development of Kabuki during the last decade of the sixteenth century.

A second influence on theater was the storytelling tradition, *Joruri*, which is a highly dramatic reading of text, accompanied by musical instruments. Vocal manipulation emphasized emotion, pathos, and bravado. These influenced the growingly sophisticated puppet theater, *Bunraku*, as well as Kabuki speech and movement, which were sometimes stylized to be puppetlike as a novelty to draw crowds away from competing genres.

The third influence was the combination of the verbal, physical, and musical, intertwined in all forms of Japanese performing arts. The verbal not only includes dialogue and narration but also "effects sounds"—nonsense syllables that express an emotional state, rhythmic chants, and elongated tones, which change pitch and volume to heighten the dramatic tension of an encounter or entrance. Dramatic physicality extends beyond the performers' movement patterns in acting and dance to the motion of scenery, the use of elevators and turntables, the cascade of cherry blossoms, and other actions of nature such as waves on the sea or, in one recent contemporary production, fish swimming in the ocean.[87]

Musical effects include a variety of drums, stringed instruments, and flutes as well as singing, both by visible players and hidden musicians in the *geza* structure on stage. The performers create patterns that indicate the time of year, weather conditions, and the presence of violent spirits. The patterns also support the emotional state of a performer during action on the *hanamichi* (a raised wooden platform extending from the stage through the audience) or during "frozen moments" called *mie*, when emotions are expressed by a sequence of movement that sharply ends in an arresting pose.

Japanese drama and dance, as well as the playing of musical instruments, require attention to all these types of aural effects. This approach can be contrasted to the predominantly verbal emphasis in much Western theater, where movement is generally understated and music limited to its realistic use (someone turns on the radio on stage) or to "curtain music," in which mood sets the scene for what is to come when the curtain opens, at which time the music stops.

The combination of these three skills—verbal, physical, and musical—requires intense and lengthy training on the part of the performers, who must master all three aspects to achieve success. The skills

also produce highly stylized theater, in which audiences are expected to respond to the technical display as well as the emotional message. Disbelief does not have to be suspended in order to appreciate these stylized events; rather, awareness of the entire entity as theater is essential.

DEVELOPMENT, AND RETENTION OF TRADITIONS

Japanese theater and dance have been united since the earliest presentations of mythological origins by the *kami*—nature's human and animal creatures—who restored balance through performance. The brief introduction that follows discusses that development from historical, structural, and performance perspectives.

The major traditional theater forms that are still presented in Japan on a regular basis are the Noh and Kabuki. These styles of theater entered a lengthy decline beginning in the Meiji period (1868–1911), when the Japanese became fascinated with Western culture and began to neglect their own traditions, embracing drama and music of European origins. Following World War II, the arts of Kabuki and Noh were barely surviving. The United States' occupation forces initially deemed them too nationalistic to allow them to be produced. The themes of the plays emphasized duty to society. Americans feared this would encourage continued deification of the imperial leadership, which the United States summarily condemned as responsible for the Japanese aggressive attempt to conquer all of Asia.

However, due in great part to the efforts of U.S. General Douglas MacArthur's aide, Faubion Bowers—who was fluent in Japanese and was responsible for investigating such potential threats—the plays and actors were recognized as cultural treasures and given clearance for continuation. Being identified as the essence of historic Japan in style, the dances were subsequently revitalized. In fact, although they are not popular theater in the late twentieth century, they have become synonymous with Japan's cultural identity, particularly abroad. In recent decades, tours of the United States have been made both by Noh and

Kabuki experienced a resurgence in popularity during the second half of the twentieth century. Here, two Kabuki dancers take part in a *michiyuki*, or dance interlude, during a Kabuki performance.

Kabuki troupes. U.S. cities with large Asian populations, including Portland, San Francisco, Los Angeles, and New York, have been host to these touring troupes. The most contemporary form, Butoh, is more enthusiastically received and attended in the United States than in Japan, where its fans are devoted but fewer in number.

Kagura

Early indigenous dance, *Kagura*, was a reenactment of sun goddess Amaterasu's original performance. According to Bowers, kagura literally denotes "god-music," dance done to placate the indigenous nature gods of Shinto.[88] Other dances still extant in this genre include *shishi* (lion dances); *tengu* (long-nosed goblins) masked dances, shamanistic performances by shrine priestesses to exorcise malevolent spirits; *onni* (masked devil dances); and other local varieties of masked and unmasked performance. The action is simple, generally involving props in the hand such as a rack of gold bells (*suzu*), or a piece of evergreen. Certain Kagura are also danced at festivals during holiday seasons. In Honolulu in the 1980s, the parking lot of a local grocery store set up tents during the Christmas season, and local residents of Japanese ancestry performed or watched these ancient dances as shoppers arrived or departed. This style tends to be dramatic and active due to the nature of its audiences and locale.

Gigaku

An early imported form, *gigaku*, a ritual dance using large, grotesque masks, was brought to Japan from Korea in A.D. 612 by a Buddhist monk. Although no dances remain from this tradition, the masks can still be viewed, and gigaku established a precedent for masked dancing in rituals as well as theatricals. Gigaku's acceptance at court by the beloved Prince Shotoku, a Buddhist of great faith, gave the dance an important role. The prince also later enjoyed bugaku, an import from Chinese court practices, although it lacked the religious significance of its predecessor.

From A.D. 710 to 784, during the Nara period, continued influxes from Chinese T'ang culture, particularly Esoteric Buddhism, occurred. Not least of these was the building in the Chinese style of the city of Nara in southern Honshu, the largest island in the chain that makes up Japan. The imported culture is also represented by the colossal bronze Buddha in the Todaiji Temple, built during this period and still standing in Nara.

In 712, the *Kokiji*, "Record of Ancient Matters," followed in 720 by the *Nihongi*, "Chronicles of Japan," were written to record the oral lore of the indigenous culture and verify the mythological relationship between the ruling family, Yamamoto, and the kami, who created the world and established humans in it.

Historical Development of Japanese Dance Forms

The common denominators in describing and analyzing style in Japanese dance forms are related to matters of physicality—including posture, gait, and timing—and use of the dynamics in tension, release, and distribution of the movements of head, chest, pelvis, and legs in combination and in relation to the spine. All styles of Japanese dance modify each of these elements to a greater or lesser degree. These elements and their specific treatment make the styles culturally identifiable as "Japanese."

Gagaku and Bugaku

During the Nara period and later, when Kyoto became the imperial/sacred city, gagaku, Japan's court music, and its dance, bugaku, became a repository for imported dances from India, Central Asia, and China—termed *Dances of the Left*—as well as from Korea and Manchuria—called *Dances of the Right*. A large number of types and stylizations abounded in both music and dance. Bugaku featured dances of the Right and Left, in which red and green costume colors distinguished the performers of each style: military/civilian dance (a categorization common to Chinese court costume, dance, and music); dances to be done to the melody or rhythm; running dances; children's dances; and so on.

In 752, to celebrate the dedication of the Daibutsu (the huge statue of Buddha) at the Todaiji temple, more than 500 musicians and dancers from many countries performed. Financial sponsorship for this auspicious event came from the court (a treasury-draining occurrence). The mixture of sound from so many different systems was unwieldy and, as a result, reform and simplification took place, which was heralded by Emperor Saga. Upon his retirement in 833, Saga turned his attention to classification of the repertory to bring order. He placed the forms into repertory categories of Left and Right, thought by some scholars to represent a Confucian perspective that is not clearly understood from this distance in time. Japan's court music and dance were influenced less and less by China after the Japanese stopped sending their embassies to the T'ang court in 894, due to its decline and weakness. Japan's culture moved ahead after the collapse of the T'ang dynasty in 907.

Although Lady Murasaki's famous novel, *The Tale of Genji*, described dancing by children and females (viewable in a few films made in the mid-twentieth century), the dancing in bugaku has traditionally been primarily performed by men, on rectangular, raised stages. These were first set up outdoors, on stone platforms near the kami of specific shrines and temples.[89] Later, inside the Imperial Palace, brocade fabric covered the platform surface, with staircases both in front and in back of the dance stage. Two large drums decorated with symbols of the Buddha stand on either side, played to signal a dance of the Right or Left—of Korean or Chinese origins.

Many of the thick silk robes are antiques that have been handed down through generations; some are three centuries old. In this dancing, the costume is more essential to the choreography than is the execution of complex actions.

Gagaku performance is still regarded as significant ritual art for the emperor's continuation and success, but it is viewed more often by foreign guests in the palace than by the general Japanese population.[90] The processional entrances are made from the right or left side, depending on the continental origin of the dance. In a slow tempo, the performers, whose feet are shod in thickly knitted silk boots soled with deerskin, stride over the carpeted floor in martial symmetry, with a weapon or ceremonial wood baton in one hand. Sliding their feet on the fabric floor, they sink into a wide, low stance with their knees apart. They shift to one leg, brushing the gesturing foot along the carpet as they swing the free leg across the standing one. As they repeat this action, they step into linear formations and successively face the four directions.

As the dancers progress, the speed and intensity of each of the two sections of dancers who follow increases, demonstrating the three-part form called *jo-ha-kyu*, which has permeated subsequent Japanese dance. "Jo" is the slow, internalized and ceremonial entry and opening dance, with the properties used in simple pathways. "Ha" (breaking away) is not only a faster section but brings more action and complexity of martial display with the weapons and formations, while retaining the calm exterior of facial expression. "Kyu" (hurried) is the action that is more realistic and recognizable as martial arts, although highly ceremonious and still with no hints of battle reflected in the dancers' expressions. The

movement vocabulary for bugaku is limited in the number of patterns as well as range of motion. These court-music and dance presentations were always intended for accomplishment by royal amateurs. The purpose of the presentations was not to produce a technical display but to honor the emperor and cultivate the soul through beautiful rituals.

There are also solo, duet, and quartet bugaku dances in the repertory. These generally have a heroic theme about a warrior or general or portray encounters with a snake (represented by a gold coiled replica placed on the stage by the performer).

The *gagaku ensemble* (the term for court music imported and developed in the Heian period, 794–1185) comprises several types of hanging and upright drums, two types of flutes, and a many-fluted mouth organ (*sho*), which must be continually warmed over a small charcoal burner to maintain its pitches. Additional melodic instruments include a type of zither that preceded the koto and a lute called a *biwa*. At the close of the Heian period, the membership of the music and dance ensembles numbered about 500, but in the twenty-first century, there are about 50.

In the Heian period, when the capital city was moved to Kyoto, the Fujiwara family was established at the center of the court; influence from China was eventually curtailed; and Japanese Buddhism (Tendai) developed. A highly delicate period developed in the Fujiwara court, which was recorded in Lady Murasaki's novel, *The Tale of Gengi*, in which intrigues and romances pervaded court life. Popular in this period were *renga*, the creation and reciting of linked lines of poetry as a court pastime; Chinese painting; and incense burning and identification.

Dengaku and *sarugaku* ("rice-field music" and "monkey music") dances for the kami of agriculture and comic dances of social amusement became popular folk forms toward the end of this period and were then avidly patronized by the nobility. This coincided with the importation of Amida Buddhism (popular, "instant nirvana" style of Mahayana Buddhism).

The flowery aesthetic sentimentality of the weakening imperial courts was referred to as "aware," a nostalgic emotionalism, gently melancholic and sensitive to the beautiful sadness of things. Aware, when toughened up by the samurai in the Kamakura period (twelfth–fourteenth century) under the reign of shoguns, metamorphosed into *yugen*, the profound, remote, indefinite, and impenetrable mysterious essence of Noh.

Gagaku is Japanese court music that has been an important part of royal ceremonies since the eighth century A.D. Here, a quartet of musicians play traditional gagaku music at a Shinto ceremony.

Noh

Following the overthrow of the Fujiwara family's imperial power by the military shogunate, during the reign of the Ashikaga Shogun in the late fourteenth and early fifteenth centuries, Noh theater was developed by Kan'ami and his more famous son, Zeami, who refined it to its high point and wrote many of the plays still performed, as well as writing *Books of the Secret Flower*. These were not theoretical models of dramaturgy, but rather acting and production manuals created only to be read by succeeding generations of the family to keep its artistry supreme.

These secret books were published and made available to the public in the 1930s and form some of the outstanding classical literature of Japan, with discussions of moral, ethical, and spiritual values as well as Zeami's professional values. Prior to its restoration in the twentieth century, during the late Tokugawa and early Meiji periods, Noh was in a

state of decline. It was thought of as old-fashioned and dull compared to the action and theatricality of Kabuki and the newly discovered Western dramas of Shakespeare. Thanks to its revival in the twentieth century, Noh continues to be performed today, although in a form and performance manner much modified from its condition in the Ashikaga era, when a cycle of five plays was performed in one day's offering. Although Noh performances don't draw large crowds, studying Noh choral singing has become a popular pastime of Japanese businessmen, and much of its dance repertory has been integrated into the more contemporary *Nihon Buyo*.

Noh theater synthesized the formal practices of Heian court dance and music: the bugaku and gagaku traditions, poetic storytelling singing, Shinto dengaku (the music and dance for rice planting and harvest festivals), and *furyu* and *sarugaku* (forms of boisterous, comic-dramatic folk performance). The subjects were lively and adventurous, and included "madness, religious ecstasy, compassion, hatred, and the calm of redemption."[91] An important central focus of content came from a new influx of Buddhist ideals from China, particularly the notion of self-derived insight to be realized through seated meditation (Zen—from the Chinese, Ch'an).

The form of the presentations of Noh completely disregarded "the normal considerations of time and space."[92] Noh was performed by monks to benefit the temples, and thus all roles were taken by men. This convention became important later in Kabuki theater in the seventeenth century, when women were banned from performing for moral reasons. The principal role or roles in the Noh play were performed by the *sh'te*, or leading actor, while a secondary, foil role, the *waki*, primarily set up the exposition of the play and briefly acted a character's role to provide interaction with the sh'te. A chorus, the *jiutai-kata*, sits on stage and at times provides both narration and dialogue for the actors through a highly stylized chanting, similar to fourteenth-century Buddhist chants. Assistants to the actors, who bring props and help with costume adjustments, are called *koken*.

Music for Noh Theater

Behind the actors and serving as prelude, interlude, and punctuation in the course of the play, sit the four members of an orchestra, which

is made up of a high-pitched flute (*nohkan*) and three types of drums. Two are played with the hand—one held at the hip (*o-tsuzumi*), one on the shoulder (*ko-tsuzumi*)—and another (*taiko*) is played with two thick beveled sticks (*bachi*) that are used primarily for dance scenes. In this ensemble—seated in view on the stage behind the actor/dancers—the musicians also insert vocal punctuations, called "hanging voices," which are an integral part of the memorized scores and learned verbally with a variety of rhythmic syllables standing for pitches on the drums.

Noh Performance Space

The Noh stage is a raised square, thrust into the audience and covered with a roof, even though it is inside an auditorium. The stage sits on a gravel surface, representative of the early out-of-doors stages. A ramp leads to the stage from upstage right called the *hashigakari*, a bridge from and to the "other world," as well as the actors' waiting room. All acting is made up of *kata*, or patterns of voice, movement, and costume uses, which are traditional. The sh'te is frequently masked; the waki, never. Other performers may appear as well, either masked or with plain faces; no makeup is worn.

Noh Play Types

The plays are of five types, so named because of the type of role the sh'te plays: God/Celebratory, Ghost/Warrior, Woman/Wig, Mad Woman (and other miscellaneous subjects), and Demon. Masks of a more refined and smaller size than bugaku were developed for the characters of each of these types. Some sh'te roles do not require a mask. Noh, as well as its successor, Kabuki, are definitely an actor's theater, centered on the performance of the lead role, rather than on a script or a director's vision.

Interlude Performances between Noh Plays

Traditionally, short comic plays, *Kyogen*, were presented between each of these five play types on every Noh program, although the demands of contemporary life make this impossible in current practice. Light-hearted and less formal, they provided relief from the intense, generally

pessimistic subject and ominous nature of the stark Noh plays. Kyogen featured servants depicted in humorous situations with their masters, who appeared as dullards and were repeatedly outsmarted about matters of food and drink. This type of performance between plays died out in the nineteenth century and was revived during the start of Showa era in the early 1930s.

Rhythm and Structure—Jo-ha-kyu Prevails

Each Noh play, as well as an entire performance of several plays, is built on a particular rhythmic flow: *jo-ha-kyu*, which was described earlier, but can be loosely described as "slow start—increasing momentum—tumbling to the end." It refers to the density and intensity of the performance as much as to the speed of things. Movement phrases take on this dynamic characteristic so that it appears that the actor, in stillness, is slowly ignited and propelled into the typical grounded gait that goes from jo to ha to kyu, sometimes over a long phrase; other times, almost precipitously. Demonic characters, who usually don't appear until the Kyu section, may telescope the action suddenly into bursts of demonic frenzy, having been discovered to be a witch or a dead warrior seeking vengeance. This telescoping closure can be startling after the long, restrained dynamic of the jo section and the subtle transition in some plays to the kyu section.

Zeami carried this rhythmic structure over from gagaku because he said it was "found in every natural phenomenon and in every kind of art."[93] A variation on this form can be found in Western drama (exposition, development, climax) as well as in music (prelude, development, coda). In the Noh, however, it is said that rather than "something happens," "someone appears." That is, the thread of narrative is sometimes very loosely tied, even for native spectators, and the play evaporates rather than culminates. Performance and expression are valued over verbally delivered values: It is a poetic theater in every manifestation.

Kabuki

The Tokugawa period falls approximately between the seventeenth and the mid-nineteenth centuries, encompassing the 16-year Genroku

period from 1688 to 1703, also called "The Floating World." Early in this time, peace was gained by the use of the sword by the warrior class (samurai) and art of all types had free reign to flourish. At the beginning of the period, the culture was agriculturally based: Trading was done in terms of measures of rice. Confucian principles prevailed: Frugality was encouraged, luxury was suppressed. When peace had been maintained long enough that the samurai class had nothing to do, it became more imperative to keep them amused by pleasures of food, brothels, theater, and clothing. When they were gathered into cities, a money economy developed. Merchants gained control over the samurai by providing money in the form of rice tickets, which they bought and sold, making profits that put the merchants in superior economic positions to their former rulers. They, too, were invested in the Kabuki, with its emphasis on emotionalism and release of the emotions from moral constraints, rather than on rational principles, self-examination, individual liberty, and political equality in the day-to-day world (as in the comparable Renaissance in Europe). Osaka and Tokyo became the leading cities during this period and the principal centers of Kabuki's two styles (domestic plays and historic, bombastic dramas).

Kabuki was first performed in the last decade of the sixteenth century by Okuni, a woman, as a new kind of Noh play. The performance was done in riverbeds and offered innovations that were avant-garde and fashionable, as well as risqué and daring. Okuni introduced a new instrument from Okinawa, the banjolike samisen, which became the principal instrument of the *nagauta* ensemble. Drums and flutes from Noh were retained, and new instruments were introduced to be played as "sound-effects music" in the geza, a concealed place offstage where its musicians performed in support of the play, rather than being in sight, onstage, as the other orchestras were. With the onset of the bunraku repertoire of puppet plays in Kabuki, the Joruri and samisen also made their appearance as an instrumental ensemble in view of the audience. Imitating puppet movement also introduced new vocabulary into the Kabuki kata.

The plays initially featured women dressed as men, males and females acting together in roles of either gender, exotic costumes (including tiger skins), and unorthodox accoutrements (such as a crucifix as jewelry). Eventually, the performance of females—and, subsequently, teenage males—was banned by the government due to rampant prostitution and

the moral decay of the samurai, who spent endless hours pursuing the pleasures of theater and teahouse. The form itself was popular enough to endure with older men performing it, and this established a realm of performance conventions such as the *onnagata* (female impersonator) and the use of exaggerated makeup to sustain extreme emotional states visually so that the actor could have the endurance to do an entire performance.

Aragoto: Dance Developed by Danjuro I of Edo

Makeup depicting anger through exaggeration of musculature and veins, with vivid color on a flat white base, appropriately embellished the role-type *aragoto*, a rough, tough character who usually was out for vengeance of some kind. The development of kata involving exaggeration and distortion to typify these role-types eventually made Kabuki a tradition that was based on intense physical training to learn specific performance, rather than psychological training to develop spontaneity and project naturalism and believability on stage, as in the theater of Konstantin Stanislavski in the West.

Kabuki Play Types

Kabuki plays are of three general types: historical, domestic, and dance. Historical include adaptations of Noh plays as well as plays based on tales from earlier periods, particularly the Heian. Kabuki heroes and heroines are frequently aristocrats and warriors. Domestic plays are rather like soap operas and focus on romances and tragedies of families of all class types, but emphasize the merchant and lower classes. Dance plays emphasize movement and music over dramatic text and can be of any subject, but tend to involve romantic attachments and animal tales.

Kabuki Performance Structure

The structure of Kabuki plays varies according to the type and subject. A play of a single title, such as *The Secrets of Calligraphy*, has many separate acts that may be performed as individual presentations because they are not linked in chronological order and are meritorious in terms of their performance values. It is not uncommon to have a program made up of a number of popular acts from completely different plays. Frequently

within an outdoor scene there is a journey (*michiyuki*), which is more or less a danced progression across the broad, shallow stage. The theater employs elaborate scenery and includes both indoor and outdoor scenes. Having developed during the rise of the merchant class and a money economy, Kabuki emphasizes fashionable dress and personal beauty. The hanamichi juts out from the wide stage into the house so that the actor is brought out close to adoring fans. Women took to copying the onnagata so as to be more feminine and *kabuki*, a term meaning "up-to-date" on the latest eccentric fashions in vogue.

PUPPET PLAYS

Bunraku, the puppet theatre where three puppeteers manipulate each character, rivaled Kabuki for the theater crowd's attention. The playwright Chikamatsu Monzaemon, frequently referred to by literari scholars as "Japan's Shakespeare," turned to writing for the puppets instead of the Kabuki actors so he could retain control over his work. With Bunraku, as the scripts would not be changed by the Joruri—the singer who also provided all descriptions and dialogue for the puppets—was accompanied by a single samisen player.

TWENTIETH-CENTURY DEVELOPMENTS

In the early twentieth century, Japanese artists developed a new form of dramatic dance, Nihon Buyo, a traditional dance as practiced on the recital stage with decorated screens as background, rather than on a theatrical set. It was created to allow women to perform either male or female parts, with the same stereotyping and movement kata as in its model, Kabuki, and borrowing elements from Noh dance. Although there is story in the dances, they are accompanied by song; the performers do not speak.

While Nihon Buyo was originally developed to allow women to study and perform, it is sometimes danced by men. Originally performances

Bunraku is Japanese puppet theater that has long been used as a way to educate the country's children about Japanese culture and traditions. Here, Bunraku puppets perform in Tokushima, Japan.

were on an amateur level, except for the *senseis* (teachers) at the head of each *iemoto seido* (school with a specific teaching approach and particular vocabulary). The level of skill has increased after almost a century of continued development, and in the United States, it has become a way for Japanese Americans to celebrate their cultural heritage without requiring performers and audiences to understand Japanese.

A highly contrasting mid-twentieth century Japanese development, *Ankoku Butoh*, "dance of the dark soul," grew out of a revolt against

Westernization in the second half of the century. The dance was also a reaction to the horrors of the effects of the atomic bombs that were dropped on Japan during World War II and the subsequent industrial poisoning of the environment.

Butoh returns to the essential relationship between a person and her/his body, a kind of "authentic movement" Japanese school of thought and action. Bodies, seminude, are whitened with rice powder and heads are shaved, resulting in an austerity and starkness of physicality. Its highly expressive nature has been described as "primal," and also as "the dance of darkness." Butoh decidedly represented the avant-garde of dance in Japan when it appeared in the 1950s. Mysterious and as intense as the Noh, with a completely different approach to movement vocabulary and expressive message, butoh draws the performer and audience into a nonintellectual, primal, body-level state of movement experience. Often grotesque, this form seeks to shock its audiences with the unpleasantness of reality and expose them to the mystery of the soul's existence.

Ankoku Butoh's primary founders, Tatsumi Hijikata and Yoshito Ono, were originally performers in Western modern dance styles, highly influenced by German dancers such as Rudolph von Laban, Mary Wigman, and Harald Kreutzberg. Their reactions against such European influences shared similar motivations of performers in the United States who formed such experimental groups as The Living Theatre, and returned to primal, physically oriented performance styles. However, the physicality of each of these movements differed as a result of their cultural environs.

Butoh shares many of the characteristics of traditional Japanese forms such as the temporal patience of the Noh theatre and the grotesqueries of Kabuki, but its reliance on physical distortion for expressive purposes is particularly colloquial.

JAPANESE DANCE TERMINOLOGY AND DESCRIPTION

Dance Types

buyo: now a general term for traditional Japanese dance, formerly known as butoh. This latter term came to be used to mean

Western ballroom dancing in the Showa era; now refers to a phenomenon that developed out of Western style modern dancing in the 1950s and is translated as the "dance of darkness."

TATSUMI HIJIKATA: CREATOR OF THE DANCE OF THE DARK SOUL

Born on March 9, 1928, in Akita, Japan, Tatsumi Hijikata attended Mitsuko Modern Dance Institute and became a member of the school's dance company in 1953. Around this time, a new dance, termed *Butoh*, arose to challenge traditional Japanese dance. This expressionist dance form was established by Hijikata, along with Kazuo Ohno and Kasai Akira. All three of these choreographers had been solo performers and butoh would develop along these lines. As Hijikata noted, "I'm convinced that a pre-made dance, a dance made to be shown, is of no interest. . . . In other forms of dance, such as flamenco or classical dance, the movements are derived from a fixed technique: they are imposed from the outside and are conventional in form."* In contrast, butoh became known for being unconventional, and it had several different styles: "Like surrealism, early butoh used distortions of nature, and like dada, it used chance as a principle of composition."** In addition, butoh performers became known for their improvisation, and performers often made it a point to engage the audience directly.

Among the sundry styles of the genre is Ankoku Butoh, created by Tatsumi Hijikata in the late 1950s. His first piece, *Kinjiki*, or *Forbidden Colors*, is believed to be the first public performance of Butoh. It was based on the novel of the same name by Japanese author Yukio Mishima. Hijikata was also influenced by the work of French author Jean Genet,

furi: pantomime movement in Kabuki dance, containing far more realistic gesture (monomane) than the other dance styles.

who expounded on the paradoxes that exist in the world. In fact, much of Hijikata's work was shaped by the literature of the time, which gave him a sense of the world around him. However, he believed that for each of his students, butoh was an individual experience and was not easily classified. He stated: "Since I believe neither in a dance teaching method nor in controlling movement, I do not teach in this manner."*** In transferring their life experiences to the dance, butoh performers can make the dance more personal.

During Hijikata's middle period, he moved away from solo male performances and included female performers while increasing the size of his productions. This new form became known as Hijikata Butoh, and the imagery evinced the natural world and Japanese traditions. As a choreographer, Hijikata focused on three principles: "First, in contrast to Western dance, he emphasized discontinuity, imbalance, and entropy instead of rhythm, balance, and the flow of kinetic energy. Second, he used traditional Japanese sources for inspiration. Third, he developed the lower body; Japanese proportions are different from Westerners', and Hijikata wanted to create movement specifically for the Japanese body."**** In Hijikata's final period, he fused elements from Kabuki with butoh. He died on January 21, 1986, in Tokyo, shortly before he was set to tour abroad for the first time.

* Anya Peterson Royce, *Anthropology of the Performing Arts* (Walnut Creek, CA: AltaMira, 2004), 194.

** Ann Dils and Ann Cooper Albright, eds., *Moving History/Dancing Cultures: A Dance History Reader* (Middletown, CT: Wesleyan University Press, 2001), 379.

*** Jean Viala, *Butoh: Shades of Darkness*. Tokyo: Shufunotomo, 1988.

**** *Moving History*, 380.

mai: originally a slow dance in which turning was prominent, capable of being done in a small space (such as on a Noh stage or on a single tatami mat); a general term also for the restrained, aristocratic dance in court kagura, bugaku, and Noh theatre.

monogatari: storytelling dance section; part of furi.

odori: rapid, free, leaping, and jumping type of dance found in matsuri (festival) performances, originally considered less artistic; later refined when it was adapted for Kabuki.

Presentational Styles of Gender Types

aragoto: "rough stuff" male character type who often wore elaborate colored makeup called *kumadori* to reveal his type and emotion (generally anger). The actor Danjuro I was responsible for the creation of this role type and conceived many of the plays that are still performed today. Sukeroku is one example of such a type, as are the three brothers, Sakura, Umeo, and Matsuo, of the one-act play, *Kuruma biki*, and the Monstrous Spider priest of the play *Tsuchigumo*.

onnagata: female role stereotype in Kabuki, whose stylized, internally rotated walk and falsetto voice make possible performance by a man. This role-playing began in Okuni's company but became essential when women were banned from the stage in 1629.

wagoto: soft-style male role, using a lot of elements of the onnagata kata to present the young, romantic hero as attractive, sensitive, and poetic.

Movement Dynamics

Here are the descriptive qualities that should be absorbed and applied while viewing and identifying, rather than memorizing vocabulary.

koshi: the use of opposing tensions in the pelvis to create a fixed axis for movement; feeling is of pressing down (postural emphasis). Posturing, meaningful poses form vocabulary of movement (shosa).

ma: the time/space between one movement and the next or one pose and the next; implies a sense of suspension and expressiveness in stillness. In Noh, it takes on the essence of "no-action" from Zen (wu wei), pulling the audience into the spirit of the actor (as Zeami said, "act 3, feel 7," or the actor says, "give space 3/10ths, time 7/10ths"), whereas in Kabuki, it is an electric stillness replete with compressed energy, projecting out from the actor to the audience (tame).

mie: a dynamic pose held at the climax of a moment in the play where all on stage are still and all focus is on the lead actor, who frequently will also cross one eye during this moment to show the great compression of tension it represents.

rank and style: as author Kimiko Gunji says, where the dancer has exceeded humanness, he is able to perform with okisa, "breadth of expression and depth of content"—kakucho.

roppo: the oversized, masculine gait used by the aragoto character for exits down the hanamichi in Kabuki. Literally meaning "flying in seven directions," it brandishes legs and arms; includes hopping and exaggerated, nonsensical sounds to bring the audience to a high moment of emotional climax as the hero or villain disappears.

spirit: breath within dancing that gives it life, strength (spiritual as communicated through the physical)—*iki.*

tame: the opposition of energy and stillness; keeping energy in, containing much more energy than needed for the space of an action.

transitions: from one part or role to another, one mood to the next, or from one body part to the next. It is the quality of movement within these transitory moments (*utsuri*) that are an important focus of interest when we compare two styles of dance, as much as the movement vocabulary itself.

Entrance and Exit Spaces

hanamichi: the bridge/ramp to the Kabuki stage that extends out through the audience; literally, the "flower path," but the figurative meaning is that the actor does his best acting there, in the midst of the audience.

hashigakari: the bridge/ramp in Noh theatre on which the actor enters and exits, from/to the other world of spirits. This pathway is on the audience's left side, going away from the audience into the greenroom, and so the figures on it distance themselves rather than put themselves in the midst of the onlookers as with the hanamichi in Kabuki.

Structural Variations in Use of Time and Energy

jo-ha-kyu: a temporal structure that began in Bugaku and has been modified and adjusted to apply in some way to each succeeding form of dance in Japan.

In bugaku, jo was the opening of a long dance (approximately 45 minutes); a slow introduction with little rhythmic precision or metric treatment of the movement. In ha, a break occurred; the movement was of a quicker nature, reflecting a relationship to the rhythms that were heard. Kyu meant a final increase in both density of action and quickening of speed.

In Noh, the jo section of the play is the opening, which encompasses introductions of the waki (the foil, secondary actor who usually is not masked) and the sh'te and any followers (*tsure*) of either waki or sh'te; it then lays the foundations of the plot through their conversation and the additions of the *ji-utai* (the chorus). Next, in the ha, the sh'te dances a stylized reenactment of a prior event and leaves the stage, after which a comic interlude (*ai-kyogen*) occurs, having little to do with the advancement of plot. The kyu constitutes the final section, with a dramatic reappearance of the sh'te, often now in his real form, generally masked, as a ghost or demon. The dance (called the mai) concludes the play, after which the other performers, chorus, and musicians leave the stage in a formal but undramatic fashion. Units of movement, such as a series of steps, will also be phrased in the jo-ha-kyu speeds.

Kabuki also takes the jo-ha-kyu timing for structure and tempos of movements and movement phrases performed in both the dance and monomane sections.

Aesthetic/Cosmic Concepts

aware: a nostalgic emotionalism, gently melancholic, with a sensitivity to the beautiful sadness of things. This taste for sentiment over vigor was typical of the late Heian period when the Fujiwara lost control of Japan, paving the way for the overthrow of Imperial rule by the samurai generals of the Kamakura period.

hana: the "flower" of a performer's art; its full, aesthetic realization. Zeami, the great perfector of Noh, considered it to be ephemeral, changing throughout a performer's life, and at the heart of dance.

kami asobi: play of the gods on earth, expressed in movement through dance (similar to the idea behind ras lila in Manipur, India).

monomane: "the imitation of things," wherein gesture symbolizes and suggests action in the "real" world. This is the dramatic aspect of movement in Noh and is associated with portrayal of the five types of characters in the plays (God, Warrior, Woman, Mad Persons, and Demon or Celebratory plays). Can be compared to nritya/natya in India.

yugen: dark and mysterious beauty portrayed in Noh, principally through the actions of the lead performer, the sh'te (also spelled shite). Includes the sense of the profound, indefinite, remote, impenetrable, and mysteriousness that is the essence of Noh. Excludes naturalistic portrayal or elaborate use of theatrical effects as is at the heart of Kabuki.

CHRONOLOGY:
THE HISTORY OF ASIAN DANCE

B.C. ————————————————

4000–2500 Caucasoid, Mongoloid, and Australoids people come together in India.

2000 Indus Valley civilization is established in two cities: Mohenjodaro and Harappa.

1700 Conquest of Indus River Valley is made by Aryas.

1500s–1000s China's Shang dynasty shamans dance—practicing divination, sacrifices, and communicating with the gods—to drive out evil and epidemics. Royal troupe had 64 dancers. *Book of Rites* establishes ceremony and dance as a way to express ideas and feelings (a Confucian philosophy).

1000s China's Early Western Zhou dynasty: Ritual music and dance pays homage to deities and celebrates important court events.

800 India's Vedas (Aryan Hymns) is written, describing early gods; the Brahmanic Age begins.

604 China's Lao Tzu's approximate birth year; he is the compiler of the *Tao Te Ching*.

551–479 Confucius, a Chinese leader, author, and teacher, establishes an ethical system of human relationships based on age and status, goodness and ethics.

500–250 *Natya Sastra* (book of Sanskrit theater and dance) is written in India.

400s	Warring States period in China brings the start of martial arts training, dances for keeping fit. Manipulation of long sleeves becomes popular. A dance is created to heal the stiffness of people suffering from a flood's dampness—connects dance with exercise as has been traditional for China's movement arts.
207 B.C.–220 A.D.	China's Han dynasty makes scarves as well as sleeves popular paraphernalia for dancing.
100s B.C.	Knowledge of Buddhism is brought to China.

A.D.

First millennium	Bronze tools and kettle drums are made in Bali.
200s	Japan's Yamato clan establishes Shinto religion: "The Way of the Gods." Priestesses dance with golden bells in forest shrines.
200s–1200s	Negara kingdoms: Indic-styled kingdoms in Southeast Asia that adopted Indian models as a result of their associations with India's university, Nalanda, which taught Buddhist/ Hindu worldview. These include Hinduism, Buddhism, caste system, performing and visual arts, mathematical concepts, and calendars (600–900). Bali's contact is in the 800s.
300s	Confucian influence enters Japan, reinforcing the need for rites: dance and music.
400s	Buddhism arrives in Tibet: Monks dance in representation and celebration of its many spirits.
450	Adoptions of Indian ideas, arts, mathematics, Brahmanism, and writing system are made in Cambodia, Vietnam, Malaya, and Java. India's *Mahabharata* and *Ramayana* are influences as well, and are integrated into local mythology and performance.

612	Gigaku, a ritual dance precursor of bugaku, brought to Japan from Korea by Buddhist monks.
Before 618	Lion dances enter China as early as pre-Tang dynasty even though China was not a natural environment for lions.
618–907	T'ang dynasty uses scarves and sleeves in dancing.
629–645	Hsuan-Tsang makes a trip to India to study Buddhism.
710–784	During Japan's Nara period, a new capital is built in Chinese style.
714	Emperor T'ang Ming Hwang initiates the Pear Garden, which later develops into Chinese Opera.
752	Five hundred musicians and dancers celebrate the dedication of the Daibutsu, the large Buddha, in Japan.
794–1185	Heian period is marked in Japan. Capital moves to Kyoto. Dengaku ("rice field music") and sarugaku ("monkey music") dances for agriculture and social amusement are created.
800s	In Java, Borobudur, a Buddhist monument, is carved by the Sailendra, while the Sanjaya build Prambanan, which has eight Hindu temples, 156 shrines, and reveres Siva. Carved gamelans in these sculptures testify to the early development of these bronze orchestras.
833	Emperor Soga of Japan organizes court dance, musical form, and instruments into Right and Left categories; *jo-ha-kyu* form is established (three increasing speeds of performance in music and dance presentations).
900s	Majapahit dynasty takes over power in Java and Bali. Islam spreads to Java, but not Bali.

1000s	Village artists perform at Balinese courts under the supervision of a religious official.
1073	A Balinese inscription describes a four-caste system of the Indian Varna type (Brahman, Kshatriya, Waisya, and Sudra).
1100s–1700s	Mogul invasions occur (Muslim influence secularizes north Indian dance).
1275–1477	Majapahit empire is at its height in Bali and Java.
Late 1300s–1400s	Kan'ami and Zeami develop all male Noh theater in Japan from Buddhist texts, with priests as actors.
1431	Thailand conquers Angkor (Khmer kingdom). Dance troupes were part of the spoils of war.
1498	The Portuguese claim land on India's west coast in Kerala.
1500s	Islam takes power in Java. Yogyakarta and Surakarta courts support meditative/religious dance, as well as dance drama.
Late 1500s	Kathakali dance drama develops in Kerala, from Kutiyattam, a dramatic form.
1660s–mid-1800s	Kabuki develops from "River Bed Noh" to popular theater in Japan.
1700s	Sukawati court reigns over Bali.
1757	East India Company gains power over northeast India; *devadasis* suppressed.
1782	Thailand king declares himself Rama I and initiates theater state.
1809–1824	Reign of King Rama II who adds the Khon dance drama to Thai performance.
1849	Bali falls to the Dutch.
1858	Great Britain takes over government of India.

Early 1900s	Indian arts revival begins under poet Rabindrath Tagore.
1900s	Nihon Buyo—Japanese dramatic dance performed by females based on Kabuki plays but with no dialogue (buyo=dance).
1915	Kebyar-style gamelan and playing style come about in northern Bali.
1918	Balasaraswati born in India; she revives Bharata natyam performance outside temples and brings it to the United States.
1920s	Movement to abolish devadasis in India.
1925	I Nyoman Mario creates new Balinese dance style, Kebyar Duduk.
1930	Ketjaq is first performed outside ceremonial domain as entertainment in Bali.
1931	Balinese dance presented at French Colonial Exposition (considered "sacred rites," not "art").
1932–1933	Bharata natyam emerges as secular solo performance of devadasi dances; now called *sadir* or *dasiyattam*.
1936	Rukmini Devi founds Kalakshetra, a school for dance and theater in Tamil Nadu (Southeast India).
1947	Dancing is outlawed in Indian temples under the "Devadasis Bill."
	India gains political independence from Great Britain.
Second half of 1900s	Bharata natyam, Kathakali, and Kathak gain recognition worldwide; in the United States, they appear on *Dancing* television series in 1960.
1950	Republic of Indonesia established.

1950s Ankoku Butoh develops in Japan in response to the horrors of World War II.

1952 I Nyoman Mario creates second Kebyar-style dance, a male-female duet called "Bumblebees."

1958 China's Great Leap Forward attempts to modernize the traditional Chinese Opera to use Chinese theater "as a weapon of the revolution." After limited success, the older operas return to the repertory.

1959 Dalai Lama flees Tibet to northern India.

Butoh dance is created by Kazuo Ohno and Tatsumi Hijikata.

1960s Sendratari-style performance is developed by SMKI (Bali High School for Performing Arts).

1962 Sendratari form is adapted from the Javanese. Balinese create a new dance drama form in kebyar style.

1964 Premier Zhou Enlai organizes "The East is Red," a national celebration of 3,000-plus performers and creators in a music and dance epic in praise of the fifteenth anniversary of the founding of New China.

1965 New Balinese sendratari is created based on the *Ramayana*.

1966 For 10 years, the Cultural Revolution in China represses artists, teachers, and writers as feudal and nonrevolutionary.

1971 Balinese Committee on dance categorization (*wali-bebali-Bali-Balihan*) created.

1978 Seven Sendrataries now performed based on Balinese Classics.

1979 A 100-year ceremony in Bali is performed to purify the universe (Eka Dasa Rudra). Dance, music, and drama play a prominent role in this island-wide ritual to purify the Universe.

1980s Documentary video *Parampara* is produced in India and distributed worldwide. It presents six major styles of Indian dance and discussions by teachers, writers, and scholars on these forms (Bharata natyam, manipuri, Kathakali, Kathak, odissi, and kuchipudi).

1984 I Nyoman Windha composes music for "Belibis" ("Wild Duck Dance"), a non-narrative dance based on the beauty and grace of the movements.

1985 Sankai Juku (Butoh group) world tour—a troupe member falls to his death in "Hanging Piece" in Seattle, Washington, in which the five members descended hanging upside down from ropes suspended between skyscrapers.

1988 Kebyar duet created for Bali Arts Center Walter Spies Festival, depicting the courtship of Birds of Paradise, a subject from Iryan Jaya (now West Papua). Colors were picked from other Indonesian Islands to represent "Unity in Diversity," the national motto of Indonesia. Choreography also integrated dance styles of other regions.

1989 Emperor Akihito's enthronement: Japan's first public performance (beyond palace viewing) of gagaku/bugaku.

1990 World Dance Festival in Los Angeles, California, brings together dancers and dance traditions from Korea, Hawaii, Australia, Java, Bali, Japan, China, Israel, Mexico, and many other nations.

1990s Asian celebrations spring up in the United States and Canada, where performers who have

immigrated or are university students share
their traditions by performing and teaching
their dances to locals who perform with them.
Javanese and Balinese gamelans, along with
Japanese Nihon Buyo performance and Indian
dance are well represented.

1993 Ngelawaag, a new dance that involves traveling
 on the road, crawling, jumping, leaping, and
 other elements borrowed from Modern Western
 dance is developed by many of Bali's young
 teacher-choreographers who have earned
 degrees from American university graduate
 dance programs.

1997 Priyamvarda Sankar of South India makes
 videotape of Bharata natyam for world
 distribution with the support of
 Multiculturalism Canada. Indian populations in
 the United States and Canada begin to teach and
 perform dances.

2006 Indian dancer/choreographer Chandralekha
 dies in Chennai.

NOTES

CHAPTER 1

1 Richard Bernstein, *Ultimate Journey* (New York: Knopf, 2001), 5.

2 Xuanzang, c596–664, *Si-yu-ki: Buddhist Records of the Western World*, Translated from the Chinese of Hiuen Tsiang (A.D. 629) by Samuel Beal.

3 Diana L. Eck, *Darsan: Seeing the Divine Image in India, 3d ed.* (New York: Columbia University Press, 1998), 3.

4 Faubion Bowers, *The Dance in India* (New York: Columbia University Press, 1953), 13.

5 Carl Wolz, *Bugaku: Japanese Court Dance* (Providence, R.I.: Asian Music Publications, 1971), 55.

6 William P. Malm, *Music Cultures of the Pacific, the Near East, and Asia* (Englewood Cliffs, N.J.: Prentice Hall, 1967), 25.

7 William P. Malm, *Japanese Music and Musical Instruments* (Tokyo, Japan: Charles E. Tuttle Co., Inc., 1959), 65.

8 Rhoda Grauer, executive producer, *Dancing* [Tape 4, "Dance at Court," (videorecording)]; a production of Thirteen/WNET in association with RM Arts and BBC-TV, (Chicago: Home Vision, 1993).

9 Allegra Fuller Snyder, "The Dance Symbol," *New Dimensions in Dance Research: Anthropology and Dance—The American Indian*, ed. Tamara Comstock (New York: Congress on Research in Dance, Dance Research Annual VI, 1972), 213–224.

10 Ibid., 214.

11 Ibid., 216.

12 Jane Belo, *Rangda and Barong, Monographs of the American Ethnological*

Society (Seattle: University of Washington Press, 1949), 16.

13 Ben Suharto, "Transformation and Mystical Aspects of Javanese Dance," *UCLA Journal of Dance Ethnology*, vol. 14 (1990), 22–25.

14 Clifford Geertz, "Religion as a Cultural System," *Reader in Comparative Religion: An Anthropological Approach*, eds. William A. Lessa and E.Z. Vogt.

(London: Addison-Wesley, 1958), 167.

15 Melford E. Spiro, *Culture and Human Nature*, ed. by Benjamin Kilborne and L.L. Langeness (Chicago, Ill.: University of Chicago Press, 1987), 187–222.

16 Huston Smith, *The Illustrated World's Religions: A Guide to Our Wisdom Traditions* (San Francisco, Calif.: Harper, 1991), 8.

CHAPTER 2

17 *Peoples of the Earth: The Indian Subcontinent*, vol. 12 (Danbury, Conn.: Danbury Press, 1973), 17.

18 The information and concepts in this section were adapted from Huston Smith, *The Illustrated World's Religions*; Diana Eck, *Darsan: Seeing the Divine Image in India*; Donald and Jean Johnson, *God and Gods in Hinduism*; and Veronica Ions, *Indian Mythology*.

19 *The Long Search*, 52 min., Paramus, N.J.: BBC/Time-Life Films, 1978, videocassette #2. A study guide accompanies the videotapes.

20 *Origins of India's Hindu Civilization*, 22 min., Huntsville, Tex.: Educational Video Network, 1991, videocassette.

21 Eck, 41.

22 Ananda Coomaraswamy, *The Dance of Shiva: Essays on Indian Art and Culture* (Sunwise Turn, 1924; reprint, New York: Dover Publications, 1985), 56–66.

23 *Cosmic Dance of Shiva*, Guilford, Conn.: Audio-Forum, c1992, videocassette.

24 *JVC Video Anthology of World Music and Dance*, Tokyo: JVC, Victor Company of Japan, 1988, videocassette 11, no. 2.

25 Jukka O. Miettinen, "Indian Influence," *Classical Dance and Theatre in South-East Asia* (New York: Oxford University Press, 1992), 4–11.

26 Ragini Devi, *Danced Dialects of India*, 2d Rev. ed. (Delhi, India: 1990), 97.

27 Padma Chebrolu, *Dances of India: Learning Bharata*

Natyam, 60 min., Cincinnati, Ohio: Cultural Centre of India, 2000, videocassette.

28 Devi, 30.

29 Devi, 37.

30 Examples of these sectional parts of a Bharata natyam program can be seen in the videocassette, *A Dance the Gods Yearn to Witness* (Montreal, Quebec: Pique-Nique Productions, c. 1997). A natya style can be viewed in the videocassette, *Balasaraswati* (Middletown, Conn.: Wesleyan University, c1998).

31 Mohan Khokar and Gurmeet Thukral, photographer, *The Splendours of Indian Dance* (New Delhi: Himalayan Books, 1988), 46–47.

32 *Circles-Cycles, Kathak Dance*. Robert Gottlieb, 28 min., Berkeley: University of California Extension Media Center, 1989, videocassette.

33 Clifford R. Jones and Betty True Jones, *Kathakali: An Introduction to the Dance Drama of Kerala* (San Francisco: American Society for Eastern Arts and Theatre Arts Books, 1970), 9.

34 *JVC Video Anthology*, Tape 11

CHAPTER 3

35 James Brandon, *Theatre in Southeast Asia* (Cambridge, Mass.: Harvard University Press, 1967), 13.

36 Edward Tylor, *Primitive Culture* (New York: Brentano's, 1874).

37 Videotapes demonstrating this style include *Celestial Drama of Siam* and *The Classical Dance of Thailand*.

38 Brandon, 138–139.

CHAPTER 4

39 Description of Wayang Topeng and Wayong Wong based on Miettinen, 91–99.

40 Stephen J. Lansing, *The Three Worlds of Bali* (New York: Praeger, 1983), 83.

41 A brief clip of Rejang can be seen in the videotape, *The Three Worlds of Bali*, prod. and dir. Ira R. Abrams; script, Abrams and J. Stephen Lansing; PBS Video: Alexandria, Va., 1981, videocassette.

42 Film Forms International, San Francisco, Sponsored by Pertamina Caltex Pacific Indonesia, Bechtel, Inc., Jakarta, *Tari-Tarian di Bali [Dances*

of Bali]: Baris Katekok Jago; Kebyar Duduk, 1975.

43 I Made Bandem and Frederik Eugene deBoer, *Balinese Dance in Transition: Kaja and Kelod* (New York: Second edition, 1981, 1995, Oxford University Press), 11.

44 Examples of such manipulation can be seen in *Learning to Dance in Bali*, a film made by Margaret Meade and Gregory Bateson from 1936–1939, published by Institute for Intercultural Studies and distributed in videotape by Audio-Visual Services, Pennsylvania State University, c. 1988.

45 *Miracle of Bali: A Recital of Music and Dancing*, prods. John Coast and David Attenborough, BBC/XEROX, 1972, University of Michigan, distributor.

46 Colin McPhee, *Music in Bali: A Study in Form and Instrumental Organization in Balinese Orchestral Music* (New Haven, Conn.: Yale University Press, 1966), 328.

47 Bandem and deBoer, 75.

48 Eugenio Barba and Nicola Savarese, *A Dictionary of Theatre Anthropology: The Secret Art of the Performer* (London: Routledge, 1991).

CHAPTER 5

49 Kefan Wang, *The History of Chinese Dance* (Beijing: Foreign Languages Press, 1985), 11.

50 Ibid., 13.

51 Ibid., 2.

52 Ibid., 28–35.

53 Ibid., 14.

54 Wai-ling Maria Chee, "References to Dance in the Shih Ching and Other Early Chinese Texts," In *Dance Research Annual XIV, Dance as Cultural Tradition*, vol. 1 (New York: Congress on Research in Dance, 1983), 126–138.

55 Huston Smith, *The Illustrated World's Religions* (San Francisco, Calif.: Harper, 1994), 124.

56 Ibid., 126.

57 Ibid., 132.

58 Ibid., 120.

59 Jen Dun Li, *The Ageless Chinese, a History*. 3d ed. (New York: Scribner's, 1978), 69.

60 Wang, 1.

61 Ibid., 4.

62 Ibid., 4.

63 Ibid., 6.

64 Mircea Eliade, *Shamanism: Archaic Techniques of Ecstasy* (Princeton, N.J.: Princeton

University Press, 1970, c1964), 433, 450.

65 John Mitchell, ed., *The Red Pear Garden: Three Great Dramas of Revolutionary China* (Boston: David R. Godine, 1973), 11.

66 Gloria B. Strauss, "Dance and Ideology in China, Past and Present: A Study of Ballet in the People's Republic," In *Dance Research Annual VIII, Asian and Pacific Dance*, eds. Adrienne L. Kaeppler, Judy Van Zile, Carl Wolz (New York: Congress on Research in Dance), 20.

67 Ibid.

68 Ibid.

69 Mitchell, 16.

70 These techniques are demonstrated *in Chinese Opera: the Opera*. Deben Bhattacharya; OET Foundation for Culture, Sussex Tapes, Guilford, Conn: Audio-Forum, c1983 and in *What Is the Chinese Opera? Old and New in Harmony*, Kwang Hwa Mass Communications.

71 *The JVC Video Anthology of World Music and Dance*, vol. 3, no. 11, China. (Tokyo: JVC, Victor Company of Japan [production company], 1988.

72 *JVC: Book II: East Asia*, 63.

73 Wang, 77.

74 Ibid., 78.

75 Ibid., 106.

76 Ibid.

77 Melvyn C Goldstein and Matthew T. Kapstein, eds., *Buddhism in Contemporary Tibet: Religious Revival and Cultural Identity* (Berkeley, Calif.: University of California Press, 1988), 6.

78 *Echoes from Tibet*. Deben Bhattacharya, dir., London: Sussex Tapes, 1992, videocassette.

79 Matthieu Ricard, *Monk Dancers of Tibet* (Boston, Mass.: Shambhala Publications, 2003).

80 Ibid., 82.

81 Ibid., 34–35.

82 Ibid., 35.

83 Ibid., 9.

CHAPTER 6

84 Summarized from chapter 8, "Japanese Mythology," Joseph Campbell, *The Masks of God: Oriental Mythology*. c1962 (New York: Penguin, 1976).

85 Campbell, 476.

86 Conrad Totman, *Japan before Perry: A Short History* (Berkeley, Calif.: University of California Press, 1981), 8.

87 Funatsu Hajime, *The Tradition of Performing Arts in Japan: the Heart of Kabuki, Noh and Bunraku*, prod., by Shin-Ei, Inc.; supervised by Nippon Steel Corporation, Tokyo, Japan: B & CI, 1989, English version, videocassette.

88 Campbell, 5.

89 Performances of bugaku on the grass and the Shinto priestess' dance with suzus are on the video *Buddha in the Land of the Kami*. Jean Antoine, writer and dir., Princeton, N.J.: Films for the Humanities, c1989, videocassette.

90 Rhoda Grauer, ex. prod., *Dancing*, WNET in association with RMArts and BBC-TV, Chicago: Home Vision, c1993, videocassette.

91 Totman, 111.

92 Totman, 11, quoting Keene.

93 Toita and Yoshida, 114.

GLOSSARY

abhinaya Expressiveness in Indian dancing, created by the performer's effective combination of verbal, physical, rhythmic, and musical aspects of the form

adat Society, how the Balinese maintain and get along together within their resources

agama Religion that permeates culture and is crystallized by water (Tirta)—used by priests as well as farmers to support human life

ananda The joy one experiences in Hinduism from union with Brahman—the infinite principle

angas Subdivisions of the gestures used to keep time in Indian music (*anudrutam, drutam, laghu*)

animism Belief that spirit exists apart from matter and can translocate (move between solid and spirit)

anthropology The study of human cultures within their contexts—physical, geographic, survival processes, and beliefs

apsara "Angel" dances of Khmer culture, adopted by Thailand. Identifying pose is on one leg, with the bent leg lifted behind, with extreme flexion that puts the heel close to the buttock. This position is also taken while kneeling on the floor, with the weight on the shin of the folded front leg and the heel touching the buttock of the back leg

archipelago Series of islands linked due to closeness

atman A single soul in Hindu, which in fact is not singular but belongs to a vast oneness of all living souls

avant-garde From the French, meaning "ahead of the crowd," or "futuristic, new," sometimes "outrageous" in its newness

avatar A person who returns to life in cycles with new identities in order to use his or her powers to assist humans in need. Vishnu returned as Parasurama, Rama, and Krishna to assist humans in dark situations. In each of these, his consort, or shakti, was also reincarnated

bedhaya Female dance for nine court women

bhakti Religious devotion, adoration of the deity; the term for a specific yoga in Hinduism

bhava The feelings stirred in the viewer of Indian dance when the performer expresses rasa by combining movement, music, words, and rhythm to arouse emotion in the audience

Borobudur A mountain of carvings of Buddha's life located in central Java

Brahmins Priests in Hinduism who served Brahma, a significant deity in the early origins of Hinduism. Brahmins are also one of the major castes in ancient Hinduism

Budhaya Balinese culture, made up of its religion, surroundings, and artistic practices that permeate it—song and instrumental music, dance, theatre, painting, weaving bamboo into beautiful products, carving, jewelry making, and mask carving

bugaku Court dancing highly influenced by China's T'ang court practices, with hundreds of musicians and dancers highly trained in a variety of styles, many imported directly from China and Korea

Bunraku Theater of puppets, each operated by three men in lifelike style, with a musician/reader acting out all the voices

buta Demons who dwell in the sea as well as "elements" of matter

caste A pyramid system of social division originally delineated according to function or job; thus, fewer people were at the top due to the unique nature of their qualifications—priests and the upper caste were responsible for memorizing and intoning all of the religious history and incantations for the community's success; military trained and protected it; managers kept it functioning; and workers provided its essential needs, both skilled and unskilled labor

ch'i The flow of physical and mental powers coursing through the body

choreography The assembling of dance movement into sequences and units that are expressive to the knowledgeable viewer

dance ethnology The study of the processes of dance within culture. Defined by Professor Allegra Fuller Snyder as "studying the process of dance in cultures." In this instance, "culture" includes a group's environment, subsistence patterns (how people acquire food and other physical needs), and beliefs of how the world operates to provide these essentials

darsan Seeing and being seen by the divine in Indian Hindu traditions

deling Puppet movement

desa/kala/patra Place, time, and context. These three must be in sync to bring success in the relationships of the Balinese with humans as well as the more significant ones, nature and the gods

devadasi Dancing temple priestesses of India, outlawed in the late eighteenth century

dewa Balinese gods whose orgins are Hindu-Buddhist and ancestral

dharma The basic principles of cosmic or individual existence, divine law; conformity to one's duty and nature

gagaku Japan's court music

gamelan The orchestra of bronze instruments of present-day Java and Bali

gati The inner rhythm or pulse in Indian music—subdivisions of 2, 3, 5, 7, or 9 to a pulse

geza A wooden structure on the Kabuki stage concealing musicians whose function is "sound effects music"

gigaku Early Buddhist masked dances brought by a monk from Korea to Japan in the early seventh century

icon Representational image whose characteristics are identified as a specific, revered cultural symbol. Examples include the image of a human or god, having symbolic paraphernalia such as an instrument, weapon, or food item that identify the specific character; an abstract representation such as the united yoni and lingam (female and male symbols); the lotus, representing Buddha; the Ganges River, a female, mother figure who cleanses and blesses

jatis Rhythmic patterns in Indian music

Joruri Storytelling with dramatic and emotional use of vocal manipulation, accompanied by music

Kabuki Highly theatrical performances emphasizing music and dance, heavily painted faces, and a ramp (*hanamichi*) through the audience for dramatically extended entrances and exits

kagura Japanese dances performed by shrine priestesses to banish bad spirits, as well as at festivals to celebrate the *kami*

kaja Moving toward the mountain/sky where the gods live

kami Nature spirits indigenous to Japan; became part of Shinto belief

kanjin Moving "easterly" on Bali—toward Mount Agung or the rising sun

karanas Body postures: centered; off-center to one side; an extreme bend to one side with knees bent, and three breaks sideways with head, ribs, and pelvis bent or shifted to opposite sides

karma The Hindu view of the sum of a human's deeds and thoughts in a lifetime, which collect to make up positive and negative baggage. This goes with her/him from one lifetime to another and must eventually achieve only positive in order to gain release from repeated reincarnation

kata Typical patterns of recognizable movement styles in each of the Japanese traditional forms that enable its almost immediate identification

Kebyar Contemporary dance developed in the early twentieth century in response to the shimmering sound of the new gamelans of the era

kelod Moving toward the ocean, where the buta, demonic spirits, dwell

Khmer Original name of peoples of the areas of Thailand and Cambodia

khon and lakhon Thai dance-drama forms, whose stories come from Jataka stories (those based on the life of Buddha) and folk tales

kotekan The explosive, unpredictable style of composition played by the gong kebyar (orchestra of brightly pitched metalaphones developed in the first quarter of the twentieth century)

kraton Javanese palaces where the sultans encouraged and sponsored slow, meditative dances

kriya Hand gestures used to keep time in Indian music/dance. These include claps, waves, and counting beats with the fingers, beginning with the little finger

lexicon How a culture thinks of and uses the body—in time, space, energy, and flow—and environment for sustaining the group both physically and psychologically to create a meaningful communication

lingam Male sexual organ, symbolizing Shiva, creator and destroyer of the world. In dance and drama the representation of the lingam is the up-held thumb, with fingers folded in toward the hand

lontars Sacred texts written on bamboo strips held together with string and tied through the holes in one end of the strips

Manora A birdlike human character (called a *kinnari*), title character in a Lakhon-style dance drama

maya In Hinduism, refers to the illusion that the world humans are born into and experience is reality, when in fact, only union with Brahman (*moksha*) is real

mie "Frozen moments" when emotions are expressed by a sequence of movement that sharply ends in an arresting pose

moksha Release, freedom from further reincarnations after liberation of the spirit

mudra Hand gestures that represent specific objects such as flower, bird, or deer; and symbolize attributes such as Shiva's lingam, the beauty and de-light of an experience, a protective spirit, or the power of an earthquake

Natya Indian theater practices, which included and emphasized dance as well as speech and dramatic action. Used as a dance term, it is expressive dance that uses music, words, and motion to reflect emotions, with little attention to rhythm/foot patterns, more to storytelling

nirvana "Heavenlike" concept in Mahayana Buddhism, where the chanting of "amida Buddha" would result in instant entrance to eternal bliss upon death

Noh Theatrical style of theatre dance introduced by Buddhist monks and developed as a dramatic dance form in a very confined space, with operatic distortion of speech and song

nritta Dance styles in India presented as pure movement, emphasizing rhythm, execution, and form over expression or ideas/story

nritya Expressive dance in India, which communicates its emotional el-ements through rhythm, dance, mime, and poetic text to reveal feelings and create *bhava* in the audience

Odalan The birthday of a local temple, held every 210 days, according to one of the many calendars followed simultaneously by the Balinese

paraphernalia (In relation to Snyder's definition) things held in the hand as one dances

phi Thai word for "spirits," the dead who return to involve themselves in human life and are transient—can return as newly born, or influence human relationships

pipad Thai orchestra

pura temple There are at least three (but, in fact, usually many more) in each village—toward the *kaja* side, in the middle, and at the kelod end

Ramakien The Thai version of the *Ramayana* (tales of Rama), brought from India by early travelers

rasa The nine states/feelings to be expressed by the traditional Hindu performer. Bhava is the associated term for the emotional experience of these states by the viewer/audience as a result of the performer's skill in presentation

sage Wise person consulted for advice

Sanghyang Spirits who can inhabit humans, as well as inanimate objects

Sastra Book, as in *Natya Sastra*, the book of theatrical practices

satori A state of intuitive illumination sought in Zen Buddhism

Sendratari Large, pageantlike performances developed first in Java and popularly adopted and localized by Balinese theater/dance artists

Shakti Female energy of an Indian god, also called yoni, represented by the unbroken circle

shaman A priest or priestess who uses magic for the purpose of curing the sick, divining the hidden, and controlling events

sutras Sayings from the thoughts and words of Buddha to his followers

tala The time cycles that make up the basis of rhythmic understanding in India's music. Time is learned orally, with individual one-syllable sounds organized and chanted to indicate specific rhythms or dance or music. The syllables are called *sollukatu*

Tandava Shiva's dance of destruction

tao The path of virtuous conduct as conceived by Confucians

tattu adavu Foot slaps in Indian dance

Trimurti Trinity (threesome) of male deities in Hinduism that included Brahma (creator), Vishnu (protector), and Shiva (destroyer)

Vedic Ideas, mythology, and songs in the books and oral practices of early Hinduism

wali, bebali, and Bali-Balihan Wali are indigenous village dances, whose origins were on the continent of Southeast Asia. Bebali dances are of Javanese Hindu and Balinese legends, dramatic and sophisticated. Bali-Balihan are secular, entertaining dances. Tourists are most familiar with this style.

wayang topeng Masked male theater dance of Yogyakarta, Java

yang The masculine active principle in nature that in Chinese cosmology is exhibited in light, heat, or dryness and that combines with yin to produce all that comes to be

yin The feminine passive principle in nature that in Chinese cosmology is exhibited in darkness, cold, or wetness and that combines with yang to produce all that comes to be

yogas Practices that lead each Hindu, according to her/his type, to freedom and union with Brahman—release from reincarnation

BIBLIOGRAPHY

Bandem, I Made, and Frederik Eugene deBoer. *Balinese Dance in Transition: Kaja and Kelod*. New York: Oxford University Press, 1981; Second edition, 1995.

Barba, Eugenio, and Nicola Savarese. *A Dictionary of Theatre Anthropology: The Secret Art of the Performer*. London: Routledge, 1991.

Belo, Jane. *Rangda and Barong*. Monographs of the American Ethnological Society. Seattle: University of Washington Press, 1949.

Bernstein, Richard. *Ultimate Journey*. New York: Knopf, 2001.

Bowers, Faubion. *Japanese Theatre*. New York: Hermitage House, 1952.

———. *The Dance in India*. New York: Columbia University Press, 1953.

Brandon, James. *Theatre in Southeast Asia*. Cambridge, Mass.: Harvard University Press, 1967.

Campbell, Joseph. *The Masks of God: Oriental Mythology*. c1962, New York: Penguin, 1976.

Chee, Wai-Ling Maria. "References to Dance in the Shih Ching and Other Early Chinese Texts." In *Dance as Cultural Heritage*. Vol. 1. Edited by Betty True Jones. New York: Congress on Research in Dance (CORD), Dance Research Annual XIV, 1983.

Chi, Ju-Shan. *Chinese Opera*. Taiwan: Taipei Committee, China Institute in America, 1961.

Coomaraswamy, Ananda. *The Dance of Shiva: Essays on Indian Art and Culture*. Sunwise Turn, 1924; New York: Dover Publications, 1985.

Craine, Debra, and Judith Mackrell. *The Oxford Dictionary of Dance*. New York: Oxford University Press, 2000.

Delza, Sophia. "The Classic Chinese Theater" in *Dance in Africa, Asia and the Pacific: Selected Readings*, 43–55. Edited by Judy Van Zile. New York: MSS Information Corporation, 1976.

Devi, Ragini. *Dances of India*. Calcutta, India: Susil Gupta (India) Private Ltd, 1962.

————. *Danced Dialects of India*. 2d Rev. ed. Delhi: 1990.

Dils, Ann, and Ann Cooper Albright, eds. *Moving History/Dancing Cultures: A Dance History Reader*. Middletown, Conn.: Wesleyan University Press, 2001.

Dunning, Jennifer. "Chandralekha, 79, Dancer Who Blended Indian Forms, Dies." *New York Times*, January 7, 2007, available online at *http://www.nytimes.com/2007/01/07/arts/07chandralekha.html*

Eck, Diana L. Darsan: *Seeing the Divine Image in India*. 3d ed. New York: Columbia University Press, 1998.

Eiseman, Frederick B. *Bali: Sekala and Niskala*. Vol. 1. Berkeley, Calif.: Periplus Editions, 1989.

Geertz, Clifford. "Religion as a Cultural System." *Reader in Comparative Religion: An Anthropological Approach*. Edited by William A. Lessa and E.Z. Vogt. London: Addison-Wesley, 1958.

Gunji, Masakatsu. *Buyo: The Classical Dance*. New York and Tokyo: Weatherhill/Tankosha, 1970.

Herbst, Edward. *Voices in Bali: Energies and Perceptions in Vocal Music and Dance Theater*. Hanover, N.H.: Wesleyan University Press, 1997.

Ions, Veronica. *Indian Mythology*. London: Hamlyn, 1967.

International Encyclopedia of Dance. New York: Oxford University Press, 1998, Vols. 1–4.

Johnson, Donald and Jean. *God and Gods in Hinduism*. New Delhi, India: Arnold-Heinemann India, 1972.

Jones, Betty True. *Dance as Cultural Heritage*. New York: Congress on Research in Dance (CORD), Dance Research Annual XIV, XV, 1983.

Jones, Clifford R., and Betty True Jones. *Kathakali: An Introduction to the Dance Drama of Kerala*. San Francisco, Calif.: American Society for Eastern Arts and Theatre Arts Books, 1970.

Khokar, Mohan, and Gurmeet Thukral, photographer. *The Splendours of Indian Dance*. New Delhi, India: Himalayan Books, 1988.

Lansing, J. Stephen. *The Three Worlds of Bali*. New York: Praeger, 1983.

Malm, William P. *Japanese Music and Musical Instruments*. Tokyo, Japan: Charles E. Tuttle, 1959.

————. *Music Cultures of the Pacific, the Near East, and Asia*. Englewood Cliffs, N.J.: Prentice Hall, 1967.

Massey, Reginald. "Chandralekha: Controversial Indian Dance Whose Ideas Challendge Convention." *The Guardian*, February 9, 2007, available online at *http://www.guardian.co.uk/news/2007/feb/09/guardianobituaries.india*

McPhee, Colin. *Music in Bali: A Study in Form and Instrumental Organization in Balinese Orchestral Music*. New Haven, Conn.: Yale University Press, 1966.

Miettinen, Jukka O. *Classical Dance and Theatre in South-East Asia*. New York: Oxford University Press, 1992.

Mitchell, John ed. *The Red Pear Garden: Three Great Dramas of Revolutionary China*. Boston: David R. Godine, 1973.

Nanako, Kurihara. "Hijikata Tatsumi: The Words of Butoh," *The Drama Review* Spring 2000 Vol. 44 issue 1.

Ramseyer, Urs. *The Art and Culture of Bali*. New York: Oxford University Press, 1977.

Royce, Anya Peterson. *Anthropology of the Performing Arts*. Walnut Creek, Calif.: AltaMira, 2004.

Smith, Huston. *The Illustrated World's Religions: A Guide to Our Wisdom Traditions*. San Francisco: Harper, 1991.

Snyder, Allegra Fuller. "The Dance Symbol." In *New Dimensions in Dance Research: Anthropology and Dance—The American Indian*. Edited by Tamara Comstock. New York: Congress on Research in Dance (CORD), Dance Research Annual VI, 1972.

Spiro, Melford E. *Culture and Human Nature*. Edited by Benjamin Kilborne and L.L. Langeness. Chicago: Chicago University Press, 1987.

Suharto, Ben. "Transformation and Mystical Aspects of Javanese Dance." *UCLA Journal of Dance Ethnology*. Vol. 14, 1990.

Tenzer, Michael. *Balinese Music*. Berkeley, Calif.: Periplus Editions, 1991 (includes compact disc).

Toita, Yasuji, and Chiaki Yoshida. *Kabuki*. Translated by Fred Dunbar. Osaka, Japan: Hoikusha, 1967.

Totman, Conrad. *Japan before Perry: A Short History*. Berkeley, Calif.: University of California Press, 1981.

Tylor, Edward. *Primitive Culture*. New York: Brentano's, 1874.

Viala, Jean. *Butoh: Shades of Darkness*. Tokyo: Shufunotomo, 1988.

Wang, Kefen. *The History of Chinese Dance*. Beijing: Foreign Languages Press, 1985.

Wolz, Carl. *Bugaku: Japanese Court Dance*. Providence, R.I.: Asian Music Publications, 1971.

Xuanzang, c596–664. *Si-yu-ki: Buddhist Records of the Western World*. Translated from the Chinese of Hiuen Tsiang (A.D. 629) by Samuel Beal.

FURTHER RESOURCES

BOOKS

Bandem, I Made, and Frederik Eugene deBoer. *Balinese Dance in Transition: Kaja and Kelod*. New York: Oxford University Press, 1981; Second edition, 1995.

Devi, Ragini. *Danced Dialects of India*. 2d Rev. ed. Delhi: 1990.

Eck, Diana L. *Darsan: Seeing the Divine Image in India*. 3d ed. New York: Columbia University Press, 1998.

Eiseman, Frederick B. *Bali: Sekala and Niskala*. Vol. 1. Berkeley, Calif.: Periplus Editions, 1989.

Gaston, Anne-Marie. *Siva in Dance, Myth, and Iconography*. Delhi; New York: Oxford University Press, 1982.

Gunji, Masakatsu. *Buyo: The Classical Dance*. New York and Tokyo: Weatherhill/Tankosha, 1970.

Holborn, Mark. *Butoh: Dance of the Dark Soul*. New York: Aperture, 1987.

Inoura, Yoshinobu, and Toshio Kawatake. *The Traditional Theater of Japan*. New York: Weatherhill, in collaboration with the Japan Foundation, 1981.

Kominz, Laurence R. *The Stars Who Created Kabuki: Their Lives, Loves, and Legacy*. Tokyo; New York: Kodansha International, 1997.

Massey, Reginald. *The Dances of India: a General Survey and Dancers' Guide*. London: Tricolour, 1989.

Miettinen, Jukka O. *Classical Dance and Theatre in South-East Asia*. New York: Oxford University Press, 1992.

Rutnin, Mattani Mojdara. *Dance, Drama, and Theatre in Thailand: the Process of Development and Modernization*. Chiang Mai, Thailand: Silkworm Books, 1996, c1993.

Smith, Huston. *The Illustrated World's Religions: A Guide to Our Wisdom Traditions*. San Francisco: Harper, 1991.

Wang, Kefen. *The History of Chinese Dance*. Beijing: Foreign Languages Press, 1985.

VIDEOGRAPHY

A Dance the Gods Yearn to Witness. Montreal: Pique-Nique Productions, c1997.
Balasaraswati. Middletown, Conn.: Wesleyan University, c1998.
Buddha in the Land of the Kami. Antoine, Jean, writer/director. Princeton, N.J.: Films for the Humanities, c1989.
Celestial Drama of Siam. Komgrit Kruasuwan, producer. Nonthaburi: Arts for Charity Foundation.
Circles-Cycles, Kathak Dance. Robert Gottlieb. Berkeley, Calif.: University of California Extension Media Center, 1989.
The Classical Dance of Thailand. Bangkok: Create Media Studio, 1992.
Cosmic Dance of Siva. Guilford, Conn.: 1992. Audio Forum.
Dances of Bali [Tari-Tarian di Bali]: Baris Katekok Jago; Kebyar Duduk. Film Forms International, San Francisco: Sponsored by Pertamina Caltex Pacific Indonesia, Bechtel, Inc., Jakarta, 1975.
Dances of India: Learning Bharata Natyam. Padma Chebrolu. Cincinnati, Ohio: Cultural Centre of India, 2000.
Dancing. WNET in association with RM Arts and BBC-TV. Rhoda Grauer, executive producer. Chicago, Ill.: Home Vision, c1993.
JVC Video Anthology of World Music and Dance. Tokyo: JVC, Victor Company of Japan, 1988.
Kalakshetra, Devotion to Dance. Producer, Adam Clapham for Griffin Productions; director, Anthony Mayer. Boulder, Colo.: Centre Productions, [1985].
Learning to Dance in Bali. Original filmed 1936–1939 by Gregory Bateson; narrated by Margaret Mead. New York: Institute for Intercultural Studies; University Park, Pa.: Distributed by Audio-Visual Services, Pennsylvania State University, 1991, c1988.
The Long Search. Munich: R.M. Productions, 1978 (13 videotapes). New York: Distributed by Ambrose Video Publishing, c1977. A study guide accompanies the videotapes. BBC and Time-Life Television.
Miracle of Bali: A Recital of Music and Dancing. John Coast and David Attenborough, producers. BBC/XEROX, 1972.
Origins of India's Hindu Civilization. Huntsville, Tex.: Educational Video Network, 1991.

The Three Worlds of Bali. Ira R. Abrams, producer/director. Ira R. Abrams and J. Stephen Lansing, script. PBS Video: Alexandria, Va., 1981.

The Tradition of Performing Arts in Japan: The Heart of Kabuki, Noh and Bunraku. Hajime Funatsu. Produced by Shin-Ei, Inc.; supervised by Nippon Steel Corporation, Tokyo, Japan: B&CI, 1989.

WEB SITES

New York Chinese Cultural Center's Chinese Folk Dance Company

www.chinesedance.org

The United States' only full-time professional school of Chinese dance. Founded in 1974, the school offers a comprehensive curriculum of more than 1,000 classes and workshops annually.

China Source

www.chsource.org

This site contains maps, links, and resources on China.

Cloud Gate Dance Theatre of Taiwan

http://www.cloudgate.org.tw/eng/

This is the official site of the Internationally Renowned Cloud Gate Dance Theatre of Taiwan, which was founded in 1973 and was the first Chinese contemporary dance company.

Indian Classical Dances

www.geocities.com/vienna/choir/3490

This site provides descriptions on classical Indian dances, along with links.

Bali and Indonesia on the Net

http://www.indo.com/interests/dance.html

This site provides information on some of the most popular classical dances of Bali and Indonesia.

South Asian Dance Faculty

www.istd.org/southasian/index.html

The United Kingdom's Imperial Society of Teachers of Dancing provides information on courses, workshops, and celebrations on South Asian Dance.

Society of Dance History Scholars

http://www.sdhs.org/index.php?option=com_content&view= article&id=131

This society provides resources on Southeast Asian Dance, including information on Balinese dance.

PICTURE CREDITS

INDEX

ABOUT THE AUTHOR
AND CONSULTING EDITOR

Author **Janet W. Descutner** is a recently retired Associate Professor Emerita of the Department of Dance at the University of Oregon who specializes in the dance cultures of India, Bali, and Japan. Other research work in this area has included collaborating with theater faculty in the creation of Asian/Western fusion performance pieces, including two original works that received national awards from the Kennedy Center American College Theatre Festival.

Descutner received two grants in the 1970s and early 1980s from the National Endowment for the Humanities, which provided both research support and instruction in Southeast India's Bharata natyam, kalaripayit, and kathakali, and Japan's nihon buyo and taiko (drumming). In 1995, she studied Balinese dance and gamelan in Ubud, Bali.

In her 32 years at the UO, she has choreographed more than 100 modern dance works, two productions of Leonard Bernstein's *Mass*, and was codirector of NorthWest Tap Consort, a jazz tap company that performed in Oregon and Washington from 1989–1996. She continues choreographing and is Artistic Advisor to The Players Project, a modern dance company based in Eugene.

Series Consulting Editor **Elizabeth Hanley** is Associate Professor Emerita of Kinesiology at the Pennsylvania State University. She holds a BS in Physical Education from the University of Maryland and an MS in Physical Education from Penn State, where she taught courses such as modern dance, figure skating, international folk dance, square and contra dance, and ballroom dance. She is the founder and former director of the Penn State International Dance Ensemble and has served as the coordinator of the dance workshop at the International Olympic Academy, in Olympia, Greece.